DATE DUE

HIGHSMITH #45230

Printed
in USA

Joan Personette: On Stage and on Canvas

JOAN PERSONETTE: ON STAGE AND ON CANVAS

CATALOGUE ESSAY
BY
NANCY G. HELLER

RETROSPECTIVE ORGANIZED BY
EXHIBITIONS INTERNATIONAL, NEW YORK

Editor: Anne Hoy
Designer: Takaaki Matsumoto, Matsumoto Incorporated, NY
Printed by Diversified Graphics Inc., MN

ISBN 1-888107-01-4
Copyright © 1998 Exhibitions International, New York

Published to accompany the retrospective organized by Exhibitions
International titled "Joan Personette: On Stage and on Canvas,"
presented by The World Financial Center Arts & Events Program,
June 16–August 9, 1998.
Exhibition Designer: Constantin Boym, Boym Design Studio
Published in 1998 by Exhibitions International.

CONTENTS

Joan Personette: On Stage and on Canvas celebrates a life of continuous artistic creativity. In the work of her consecutive careers—as a costume designer for Broadway's musical stage and as a painter—Joan Personette has given pure pleasure. Bringing those careers to the broader attention they deserve is this exhibition's goal.

Joan Personette: On Stage and on Canvas expands on the 1990 retrospective of her painting at the National Museum of Women in the Arts, Washington, D.C., and presents over sixty artworks from 1920 through the late 1980s. Substantial space is devoted to Personette's achievements in the theatrical arts, which the Washington exhibition represented only minimally. In addition to her paintings and costume renderings, this exhibition includes photographs, videotape, and posters evoking the atmosphere of New York's musical theater and art worlds around mid-century, arguably their liveliest years. In both these worlds Personette displayed her immense joie-de-vivre and energy, discipline and talent, humor and modesty. That modesty is among the reasons her work has not until now seen the spotlight. Her talent, amply on view here, is the reason it should.

This exhibition and accompanying catalogue are the result of the dedicated work of many people. We wish to thank our exhibition curator, Nancy G. Heller, Professor of Art History, The University of the Arts, Philadelphia, who selected the artwork and wrote the comprehensive and vivid catalogue essay. For generous research assistance in their archives, we would like to thank the staff of the Billy Rose Theatre Collection, New York Public Library for the Performing Arts; Marty Jacobs, Acting Curator, Theatre Collection, Museum of the City of New York; Brooks McNamara and Reagan Fletcher, Director and Assistant Archivist, Shubert Archives; Annette Fern, Research and Reference Librarian, Harvard Theatre Collection; and Michael Zaidman, Director and Curator, National Museum of Roller Skating. We also appreciate consultations with Susan Sterling and the staff of the National Museum of Women

in the Arts, and Charles Buckley, former director of the St. Louis Art Museum. We especially thank Jack Dreyfus for his unfailing devotion to this project and the staff of the Dreyfus Medical Foundation, particularly Teresa Quinlan and Helen Raudonat, for their assistance with our many requests. Above all, we are deeply indebted to the artist herself who has graciously allowed us into her life, giving unstintingly of her time and lending many of her artworks and photographs to the exhibition.

With her customary commitment and professionalism, Leigh Snitiker of Exhibitions International, New York coordinated the exhibition and its catalogue, assisted by our staff members Jan Spak, Joan Rosasco, Dorys Codina, and Suzie Lee. A special thank-you goes to Anne Hoy for her intelligent and insightful editing of the catalogue and brochure. In addition, we are grateful to Takaaki Matsumoto of Matsumoto Incorporated for designing a beautiful catalogue, brochure, and poster.

David A. Hanks
Director
Exhibitions International, New York

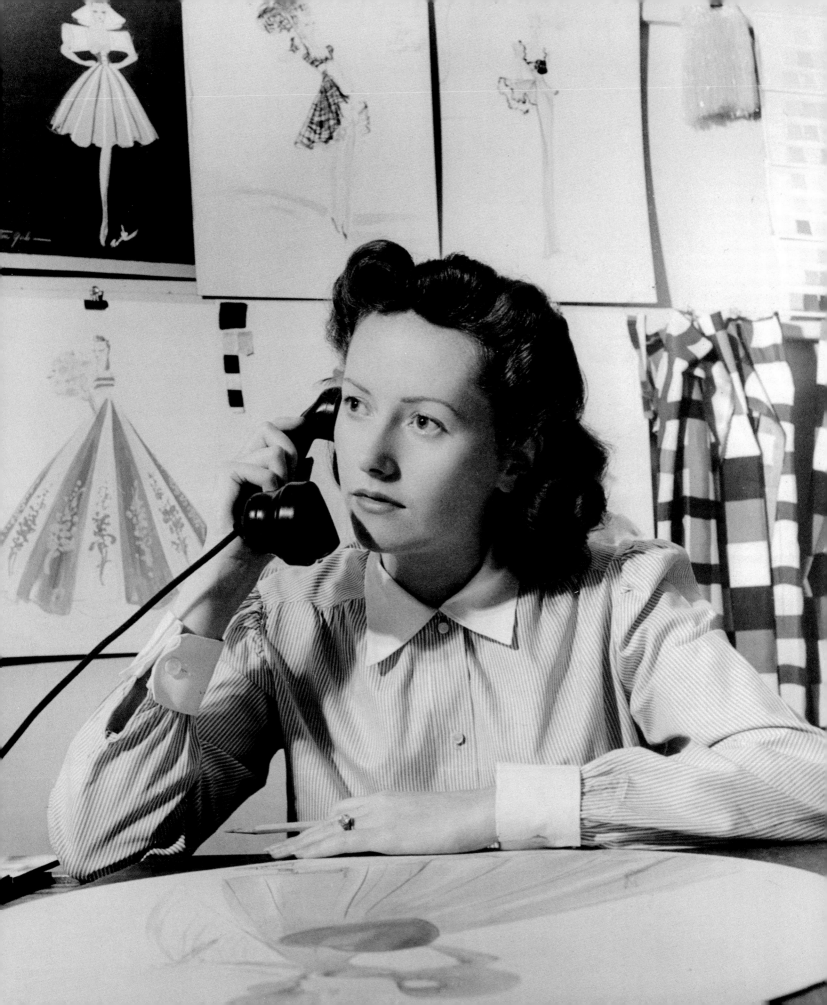

JOAN PERSONETTE: ON STAGE AND ON CANVAS

BY

NANCY G. HELLER

In an oft-quoted statement, the French painter Henri Matisse said he aimed for "an art of serenity, devoid of troubling or depressing subject matter, . . . a soothing, calming influence on the mind, something like a good armchair which provides relaxation from physical fatigue."[1] Indeed, despite the radical nature of much of his oeuvre, Matisse produced a body of work based on the celebration of color, light, and sensuality. For those who prefer their art with a more obvious intellectual subtext, Matisse may seem somewhat superficial. But, as actors love to say, comedy is harder than tragedy, and it is equally difficult to create visual art that inspires joy.

During her six decades in the creative arts, Joan Personette spent many years designing costumes for what are known as light theatrical entertainments—revues, skating shows, and the like, rather than the so-called "legitimate" Broadway theater, traditional ballet, or avant-garde performing arts events. As a result, her work, and that of her myriad counterparts, has too easily been dismissed by both critics and theater historians. Similarly, her studio art, which she began to produce on a full-time basis in 1957, has received limited critical attention. This is partly because Personette did not actively seek gallery representation, but it may also have resulted from the dismissive attitudes of many within the art establishment toward middle-aged female artists, and toward individuals of either gender who fail to follow prevailing art world trends. In addition, Personette has consistently preferred to revel in the freedom to make figure paintings, landscapes, and abstract collages that explored the aesthetic issues that interested her.

The purpose of this essay—and the exhibition that accompanies it—is to demonstrate the remarkable range of Joan Personette's work, in both her costume renderings and studio art, while providing a broader cultural and art-

fig. 1. Joan Personette in her Roxy Theatre studio, 1940

historical context within which to view it. Her consecutive careers as a designer of theatrical costumes and a full-time studio artist shed light on a number of broader issues. A study of Personette's professional life inevitably touches on the changing position of women in 20th-century American theater. It also involves shifting attitudes toward popular forms of entertainment, once dismissed as ephemeral and insubstantial, now deemed worthy of scholarly study. It concerns the ever-expanding definition of art, which has turned costume renderings into collectibles and enabled viewers to consider them for their artistic merits, as well as their purely historical interest.

Early Life and Art

There was nothing in Personette's upbringing to suggest that she would find herself a Broadway designer or a full-time painter. The only child of Edith and Leslie Personette, she was born and reared in Irvington, New Jersey, where her mother was a full-time housewife and her father worked for a power company, repairing high-tension wires. The family's modest life-style provided Joan with no particular exposure to the visual or performing arts.[2]

Personette describes herself as shy, and insists that she never wanted to go on the stage. But as an adolescent, she developed a passion for movies and a strong ambition to design costumes for both stage and screen. She was obsessed with Clara Bow (1905–1965), the notorious "It Girl," who between 1927 and 1930 was one of the top five Hollywood "draws," adored for her red-haired beauty and her air of both vulnerability and sensuality. Personette— herself an attractive redhead—felt so drawn to the star that she worked for local movie theaters after school in exchange for posters and memorabilia with which she plastered her room. To this day, Personette keeps a framed photo of Bow above her studio door, and she painted a four-panel homage to her idol.

Personette had her first academic exposure to art as a senior in high school, but the teacher encouraged students to concentrate on calligraphy. Personette had other ambitions: she had noticed a sign on the school bulletin board advertising a contest for a scholarship to attend the New York School of Design, which offered a two-year program in fashion design. Personette developed her own portfolio of drawings, including one of a sophisticated woman in a tailored suit, complete with the era's standard hat, gloves, and a fur piece draped casually over one arm (fig. 2). She won.

For the next two years Personette spent her mornings in drawing class, learning all the points of fashion illustration and the many principles of dress design. Afternoons were devoted to fine art. Here, for the first time, she worked from a live model, and in oils. *Negro Chieftain*, 1933, a bust-length portrait of a school model, is remarkably assured (fig. 4). It demonstrates Personette's gift for bravura brushwork, her appreciation for the sensual quality of pigment, and her ability to convey a sense of a subject's personality. She recalls that the model had "a wonderful bearing," and the man's dignified, almost haughty, quality comes through clearly. Her painting teacher was also the first person to praise Personette for her command of color.

Following graduation from design school in 1934, Personette spent the next five years in the New York fashion world. After working briefly for an undistinguished house on Seventh Avenue, in 1935 she was hired by Milgrim's, a high-end women's specialty shop on Fifth Avenue.[3] There Personette developed a keen visual memory by going to New York showings of the latest European fashions (where store representatives were forbidden to do any sketching) and then racing back to her office to draw up to eighty outfits from memory, so the staff could copy them. After two years at Milgrim's, Personette was given her own studio to design evening gowns.

Milgrim's also led Personette to the theater. Soon after she was hired, the store's principal designer, Sally Milgrim, suggested that Personette enter a "Joan Crawford Look-Alike Contest" being sponsored by *Modern Screen* magazine.

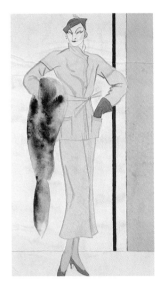

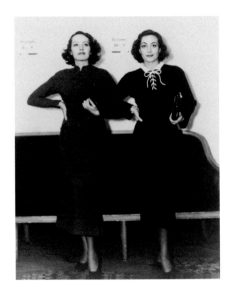

fig. 2. Woman in Suit with Fur
Piece, *c. 1931, watercolor on paper,*
19 ¹/₂ x 10 ¹/₂ inches

fig. 3. Joan Personette and Joan Crawford, 1935

Although Personette denies that she resembled Crawford, the judges thought otherwise—and she won. Her prize was a meeting with the star and the publication of a story with photographs of Crawford and herself in the December 10, 1935 issue (fig. 3). It was another co-worker at Milgrim's who in 1939 introduced Personette to a producer at the Roxy Theatre, a noted Manhattan movie palace. He suggested that she take a sample of her sketches to Gae Foster, who choreographed the Roxy's live stage shows. Foster was unhappy with her current costume designer and ready for a change. Two weeks after they met, she phoned and asked Personette to come to work at the Roxy. She went, and stayed there for fifteen years (fig. 1).

Costume Designs for the Roxy Theatre, 1939–54

For many Americans, going to the movies today means driving to a suburban shopping mall and paying $8 or more to see a single film, usually in a colorless, shoebox-sized room, on a miniature screen. Thus it is virtually impossible for us to imagine the fabulous urban movie palaces of the 1920s and thirties. For their lucky patrons, fifty cents bought a ticket to a feature film, with a newsreel, a travelogue, cartoons, and a forty-five-minute stage show, complete with elaborately costumed dancers, singers, comedians, jugglers, and frequently a dog act. These impressive entertainments took place inside enormous and sumptuously appointed buildings for which the term "palace" was entirely appropriate.

By the 1920s moviemaking had become an enormous industry in the United States and theater builders vied to outdo one another, creating ever-larger and more lavish structures—an estimated twenty thousand in that decade in the gamut of exotic styles.[4] The Roxy Theatre, which opened in 1927, outdid them all. Known by the nickname of its first manager, the innovative entrepreneur Samuel Lionel Rothafel,[5] this fabulously ornate, pseudo-Spanish Renaissance

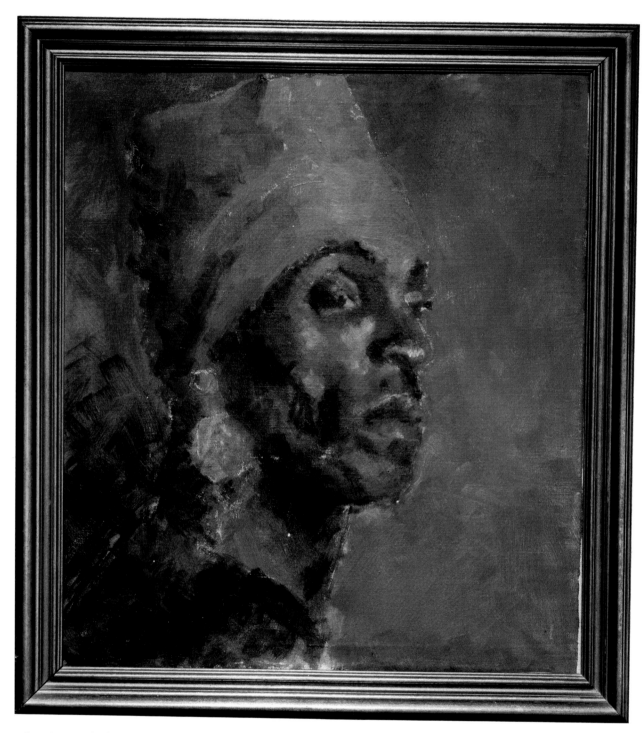

fig. 4. Negro Chieftan, *1933, oil on canvas, 18 x 15 ³/₄ inches*

edifice, designed by Walter W. Ahlschlager, with decorations by Harold Rambush, boasted over 6,200 seats: it was the largest theater of its time in the United States (fig. 5).[6]

The Roxy also had an enormous stage, fitted with the latest lighting, sound, and set-changing technology; a 110-piece orchestra; and a massive pipe organ with separate consoles so three musicians could play it simultaneously. An advertisement in the *New York Times* listed still more impressive features, including "the latest word in scientific air-conditioning, . . . spacious elevators to the balcony, . . . a plant sufficient to light and power a city of a quarter million, . . . and a staff of attendants thoroughly organized and drilled under the direction of a retired Colonel of the U.S. Marines" (fig. 6). In addition to numerous offices, five floors of dressing rooms, and a music library of more than fifty thousand orchestral scores, the Roxy had its own infirmary, a special "green room" for animal acts, a private health club for the director, and a radio studio from which Rothafel broadcast the variety program he had been hosting since 1922. Located at Seventh Avenue and 50th Street, this "Cathedral of the Motion Picture" reportedly cost $10 million to build.[7] It opened to the public on March 11, 1927, as excited crowds, held behind barricades by 125 policemen, were dazzled by a parade of famous actors, politicians, and other celebrities, who in turn were entertained by *The Love of Sunya*, starring Gloria Swanson, introduced by the resident choral and dance troupes, several hundred performers strong.

From its premiere, the female dancers—initially a group of thirty-two, under the direction of Russell E. Markert—were an integral part of the Roxy experience. Markert had originally established this chorus line in St. Louis in 1925. Two years later Rothafel brought the "Missouri Rockets" to New York, and renamed them after their new home. But when Radio City Music Hall opened in 1933, Markert moved his line there and gave it its most famous label: "the Rockettes." Meanwhile, another line was formed back at the Roxy, with Gae Foster as its director and choreographer.[8]

Under Foster, the Roxyettes—pared down to twenty-four "girls" (as such performers were, and still are, called)—set new standards for glamour, versatility, and derring-do. A former precision line dancer in her native California, Foster had worked her way up from the chorus to the position of dance captain, and then production assistant; by 1928 she had her own precision dance teams.[9] In her dual roles as the Roxy's dance director and production stage director, Foster was ultimately responsible for every aspect of the theater's stage shows. Contemporary accounts indicate that she was widely respected by the management, cast, and crew, because Foster was intimately familiar with every element of theater craft, from makeup to lighting.[10]

By the time Joan Personette joined the Roxy Theatre staff in 1939, the reputation of Gae Foster's Roxyettes was firmly established, and even threatened to eclipse that of their principal rivals at Radio City. As many contemporary writers pointed out, the Roxyettes worked much harder than their Music Hall counterparts.[11] While the Rockettes have always been famous for their precision tap dancing and high kicks, they rarely do anything else. Roxyettes, on the other hand, seldom did the same thing twice. Gae Foster devised a seemingly endless array of novelty numbers, generally built around complicated props (fig. 7). For $35 a week in 1939, working from 9:00 AM to 10:30 PM, doing four shows a day (five on Saturday), every day for six weeks at a time, the Roxyettes performed routines that involved riding bicycles, unicycles, pogo sticks, and hobbyhorses, or dancing on roller skates, seven-foot ladders, stilts, and skis. There was even a show-stopping routine featuring Roxyettes dancing atop huge wooden balls (fig. 8 and pl. 1). One *New Yorker* contributor was moved to confess that he went to the Roxy "just to see the chorus I think they are the most talented girls in the world, and I love them."[12]

But even the most amusing and impressive dance routines would have been uninspiring without costumes that

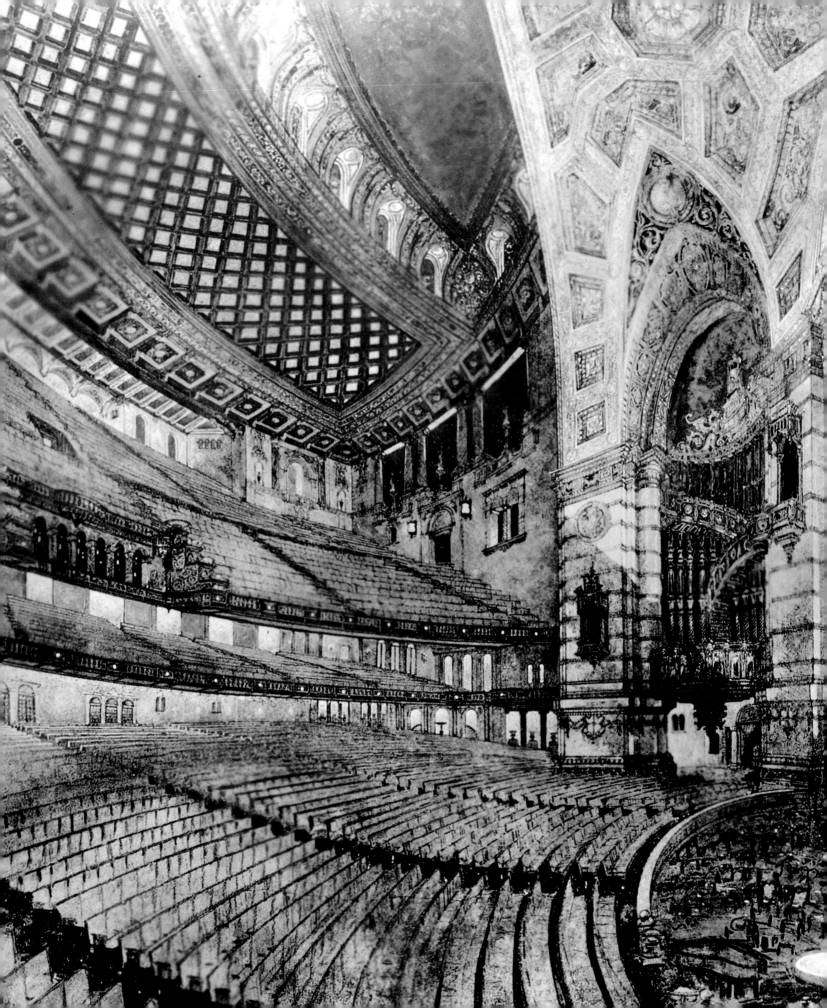

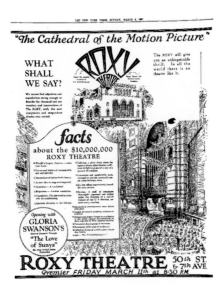

fig. 6. *Advertisement for the Roxy Theatre*
from the New York Times, *March 6, 1927*

showed them off to the best advantage. It was Joan Personette's job to create these costumes—in an extraordinarily broad range of styles, at a mind-numbing pace. Gae Foster's Roxyettes appeared in three different numbers during every show, and the shows changed every time the movie did. Typically, this happened once a week; three weeks was considered a long run for a film. Roxyettes also did frequent "walk-ons," in which a small number of them in lavish dress would escort that day's special guest onto the stage. In those years, guests included Desi Arnaz, Victor Borge, Abbott and Costello, the Nicholas Brothers, and Milton Berle. This meant that, in a typical year, Joan Personette would have to design well over a hundred different costumes for the Roxyettes, not counting the clothes she created for the twelve male chorus dancers who occasionally appeared with them, as well as the clothes worn by all the comedians, jugglers, acrobats, and myriad others who participated in the Roxy shows. Personette says she designed the costumes for "everything that was on that stage"—even the dogs and the trained seals.

To design the Roxyettes' costumes for any given number, Personette would first consult with Foster to determine the theme involved. Popular themes were the patriotic/military scene, of obvious appeal in wartime (where the girls were dressed as soldiers, or sailors, and often carried flags), South American numbers (used, for example, to complement a film starring Carmen Miranda), the Southern plantation (for which the girls danced in five-foot-wide hoop skirts), the gay nineties, the Wild West, Halloween (where skeletons danced in the dark in luminescent costumes), Hawaii, and other exotica. They had to perform holding everything from fencing foils to golf clubs and parasols; in one routine, the Roxyettes impersonated a railroad train. They were sometimes costumed as animals (cats seem to have been especially

fig. 5. *Presentation drawing of Roxy Theatre interior, c. 1927, designed by Walter W. Ahlschlager*

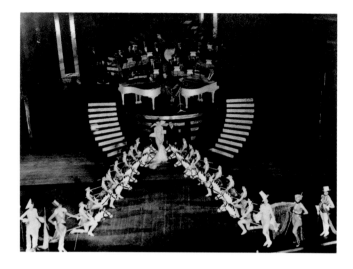

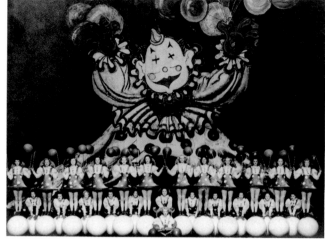

fig. 7. Roxyettes with hobbyhorses, 1940s

fig. 8. Roxyettes dancing on balls, 1940s

popular; pl. 2); but for nightclub scenes and for the walk-ons, they wore low-cut, slinky gowns trimmed in rhinestones, feathers, and fur. Owing to her experience designing evening clothes, Personette knew how to cut and drape such garments (fig. 9 and pls. 3 and 4). But instead of trying to create a one-of-a-kind dress that would flatter an individual when she wore it to a party or a restaurant, Personette had to invent clothes that looked attractive on a woman seen from a considerable distance, on a huge stage, next to twenty-three other women wearing the identical dress, while all of them were dancing.

As a theatrical costumer, Personette had to consider issues that couturiers can safely ignore—most notably, the effects of stage lighting on the textures and colors of her fabrics. She also had to make costumes that were practical— safe, comfortable, and durable. Few evening gowns could stand up to the kind of wear and tear these clothes got, thirty-one times a week.

Once Foster had approved the sketch for a given costume, Personette's assistant would buy fabric samples and baste together a model garment. The final costumes were then fitted and sewn by Personette's staff of twenty-five. When the budget did not allow for new items, Personette had to alter an existing set of costumes to fit an entirely different number. And she could never relax; given the Roxy's uncertain schedule, she always had to plan several shows ahead.

The length of Personette's tenure at the Roxy indicates how highly she was regarded by the management of that theater. New York critics also recognized the caliber of her work. During Personette's first year there, at a time when it was unusual for writers to mention theatrical costume design, *Variety* stated: "There's been a noticeable improvement in the scenery at the Roxy; also in the costuming." Other *Variety* columnists called her costumes "striking," "outstanding," and "especially effective."[13]

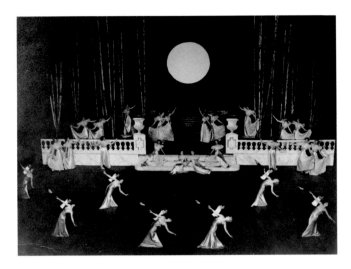

fig. 9. Roxyettes in evening gowns, 1940s

Although the Roxy costumes themselves no longer exist, something of their original impact can be gauged by looking at contemporary photographs, such as those taken by Jack Partington, Jr., official staff photographer for the Roxy.[14] More importantly, many of Personette's costume renderings remain.[15] Since a designer's work is largely done once she produces her drawings, these renderings are the most valuable records of Personette's art from this fifteen-year period.

Taken as a group, Personette's Roxy costume renderings exhibit the same essential characteristics as fashion illustrations and theatrical renderings of the time. A single figure is centered on the page, with her facial features sketched in summarily or left out altogether. The background is blank, or a few brushstrokes may be used to help locate the figure in space. Where relevant, props are included: a top hat, a candle, a fencing foil, a cane. The bodies of Personette's figures are highly stylized. The women all have impossibly tiny waists, long legs, elegant hands, and minuscule, sharply tapering feet, reflecting the then-current trend in fashion illustrations toward featuring women whose proportions are obviously unreal and bear very little resemblance to those of the typical American chorus girl of the period. The renderings illustrated here give some sense of the gamut of Personette's Roxy designs, from sophisticated elegance to comic fantasy.

Only some of Personette's renderings are signed; a few have small fabric swatches attached to one corner of the drawing or include brief pencil notations—generally the names of the dancers who were to wear a particular costume. These renderings reveal Personette's knack for inventing strong contrasts of color, texture, and silhouette, which would carry visually to the back of the house, and her ability to convey many different theatrical types convincingly, from urban vamp to Southern belle. Her skill with materials served her well in these renderings: Personette seems equally

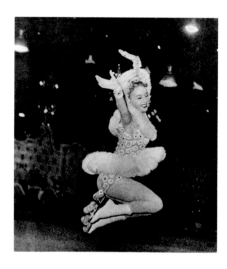

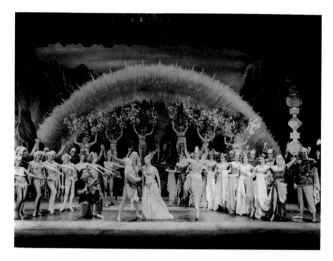

*fig. 10. Gloria Nord of the Skating Vanities
from* Point du vue: Images du monde,
May 4, 1950

fig. 11. "Wagnerian" scene from Two on the Aisle, *c. 1951*

comfortable describing a bouffant skirt with just a few brisk strokes of her brush, or taking the time to indicate, in painstaking detail, the embroidery patterns on a folk costume. On stage, the Roxyettes were seldom still, and Personette's renderings reflect their nearly constant motion—figures are often shown striding purposefully forward—or when they are relatively static, the artist will emphasize a bent knee, the gesture of one arm, or the exaggerated curve of an attenuated torso.

As the Roxy's costume designer Personette held an important position within a popular institution. Nevertheless, she and the costume designers at Radio City and the many other movie palaces of those times were still affected by the power of several hierarchies, all of which placed the kind of work she did near the bottom. Because the Roxy was not a "legitimate" theater, for example, Personette was not eligible to compete for the Tony Award, which had been established in 1947, and remains the premier form of recognition in American theater.[16] More tellingly, costume designers have always received the least respect of the three principal categories of theatrical designers, after those concerned with scenery and lighting. One indication of this hierarchy is the order in which Tony Award categories have traditionally been presented. Performers and directors are always cited before backstage personnel. In the first Tony Awards ceremony, the prize for outstanding costume design was awarded dead last. And since then, the costume design Tony has almost always been awarded last, or next to last.[17] In addition, because most costume designers have historically been women, theatrical producers long ago established the practice of paying them far less than other designers. This remains true today, although labor organizations are working toward erasing this discrepancy.[18]

Meanwhile, since Personette's time at the Roxy, tremendous changes have occurred in people's attitudes toward theatrical costume renderings. In the early years of this century, even the most beautifully executed and painstakingly

fig. 12. Poster for Tallulah Bankhead's nightclub act at The Sands, Las Vegas, 1953, 10 1/2 x 6 3/4 inches

detailed drawings were regarded as simple working tools. Such sketches were routinely discarded, once the costumes had been completed, or the production finished its run. If they were kept, costume renderings were stored unceremoniously, often with no accompanying documentation. Today, although some costume designers continue to treat their renderings with relative indifference, many consider them valuable artworks to be carefully conserved, labeled, and displayed. Indeed, theatrical costume renderings are now being collected; drawings by prominent designers are frequently sold by Sotheby's and other auction houses.

Additional Costume Designs, 1940–53

Though her work at the Roxy was demanding, Personette took on additional projects several times during her years there: designing the costumes for several television programs, one nightclub act, a series of skating revues, and two Broadway musicals. At the same time, her personal life was becoming more complex. Soon after she was hired by Gae Foster, Personette married Jack Dreyfus, who, a decade later, after exploring jobs in sales and a number of other fields, became a prominent Wall Street portfolio manager and founder of the Dreyfus Fund. Although he was not personally involved in the performing arts, Dreyfus shared Personette's passion for movies, and he has always been an ardent admirer of both her costume designs and her more recent art. In 1942 their only child, John, was born. One year later Personette and Dreyfus were legally separated; they eventually divorced, but remain close friends.[19]

Joan Personette's first foray into theatrical design outside the Roxy was with *Hellzapoppin*, an old-fashioned, vaudeville-style revue that played at New York's 46th Street Theatre between 1938 and 1941 and broke box-office records, becoming the third-longest-running musical in Broadway history.[20] *Hellzapoppin* consisted of a series of short

comedic sketches written by the vaudeville veterans Ole Olsen and Chic Johnson, interspersed with dances and songs. During the show's third year, Personette was brought in to "freshen" the costumes.[21]

Personette played a much larger role in her second extra-Roxy assignment: designing costumes for the troupe called the Skating Vanities.[22] By 1940 elaborate ice skating shows—including the Hollywood Ice Revue, starring the Olympic gold medal-winner Sonja Henie, and another group called the Ice Follies—were a rage. Based on their success, Harold Steinman, a New York promoter of theatrical and sports events, organized the first comparable extravaganza on roller skates. When it premiered in Baltimore on January 7, 1942, the Skating Vanities featured a cast of one hundred, headed by Gloria Nord, a twenty-year-old former ballet dancer from California, billed as "the Pavlova of roller skating." The show was an immediate hit, and the Vanities lasted through 1956, playing all over the United States and Canada, with five European tours and a stint in South America. They also appeared in the Betty Grable film, *Pin-Up Girl*.

Initially the Skating Vanities consisted entirely of roller skating in solo, duo, and large group numbers, arranged by Gae Foster. Later editions of the Vanities added such nonskating acts as comedians and guest musicians. A 1944 review of the Skating Vanities at New York's Madison Square Garden called it "a lively and entertaining show," extolling Gloria Nord's theatrical presence and singling out the "attractive costumes by Joan Personette, which added to the evening's pleasure."[23]

Her work with the Skating Vanities also provided Personette with her first opportunity to travel abroad. At various points, she spent time with the troupe in Paris, Hamburg, and Moscow. Despite a full working schedule, she managed to visit art museums; she remembers the Hermitage in particular.

As with her Roxy designs, Personette's renderings for the Skating Vanities cover a broad range of types. Period photographs show the male skaters dressed in spangled, nightclub-style outfits or severe, unadorned shirts and trousers; the women in the ensemble wear Middle Eastern harem garb, skirts with blazers, or bunny suits. For Gloria Nord, Personette created gracefully flowing short dresses with sparkling bodices and delicate floral headpieces, as well as fluffy white, cloudlike affairs that emphasized her youthful face and figure (fig. 10 and pl. 5). One of Personette's renderings for the Vanities shows a woman in a short red skirt with matching top, accentuated by a fur hat and cuffs (pl. 6). The white polka dots on the skirt echo the background's flakes of falling snow, another indication of Personette's interest in movement.

Meanwhile, Personette had been engaged to design the costumes for *Two on the Aisle*, starring the great comedian Bert Lahr and a sexy young singer, Dolores Gray.[24] Directed by Abe Burrows, this revue, in two acts and nineteen scenes, had sketches and lyrics by Betty Comden and Adolph Green, with music by Jule Styne. It opened at the Mark Hellinger Theatre on July 19, 1951, and was a huge success. *Newsweek* said it was "a pleasure to have around," and the *New York Times* agreed, calling it "an excellent, light revue."[25]

The show featured the usual complement of gorgeous dancing girls and humorous supporting players, but it was primarily a showcase for the incomparably talented Lahr. Within the space of 140 minutes he transformed himself into nineteen different characters: among them, Lefty Hogan (an imaginary former pitcher for the New York Giants), a cross-eyed amorous gaucho, a trash collector in a city park, a spaceman, a Wagnerian opera star, and Queen Victoria. *Two on the Aisle* put Bert Lahr's face on the cover of *Time* magazine,[26] and Joan Personette's name into theater history

fig. 13. Art Students League teachers and students, photograph taken between 1957 and 1964. Joan Personette: last row, third from left; Harry Sternberg: last row, second from left.

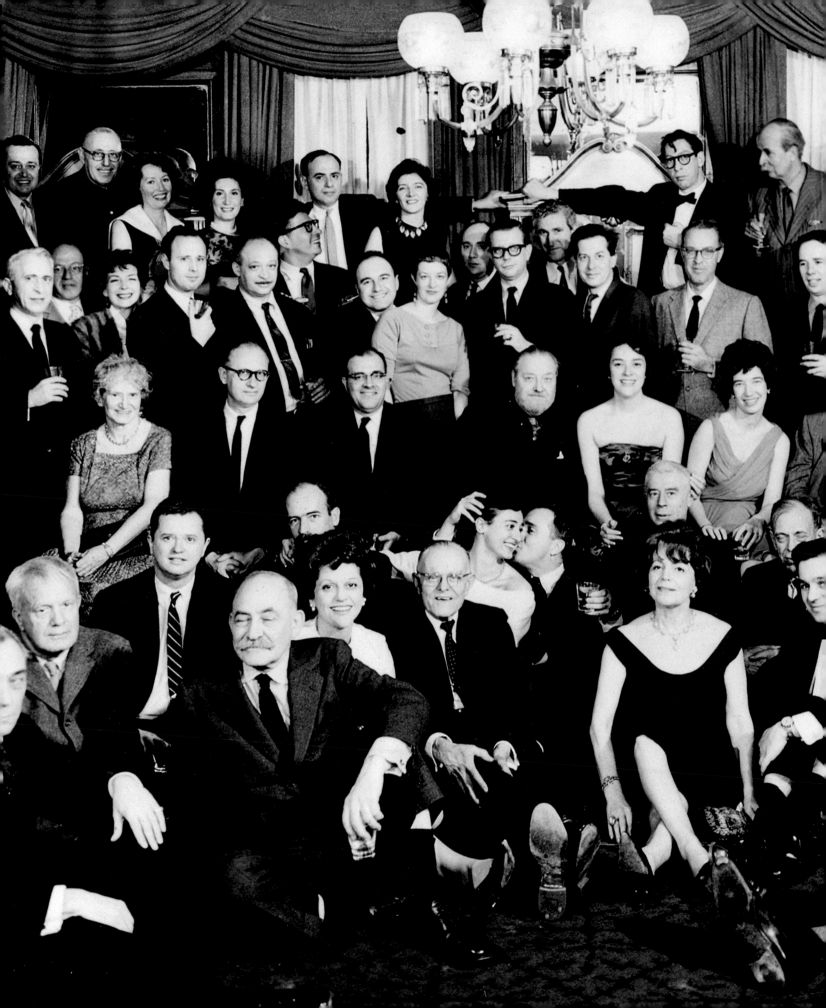

books. The show gave Personette the chance to demonstrate her own versatility. After a dozen years at the Roxy, the requirements of nineteen scenes barely taxed her imagination. There was little creativity involved in conceiving Queen Victoria's ensemble or the Giants uniform.[27] But Personette outdid herself in the science-fiction sketch—putting Lahr, as "Captain Universe," into a ridiculous, Superman-type outfit with a television aerial on his head. Best of all, according to contemporary critics (and surviving photographs), were the costumes for Lahr as the operatic Siegfried, sporting a horned helmet and a fur loincloth over his long red underwear, and playing opposite Ms. Gray, who made her mark in a slinky, see-through gown. Both were surrounded by a bevy of showgirl Valkyries, some of whom have decorative greenery sprouting from their upraised hands (fig. 11 and pl. 7).

Clearly, much of the success of *Two on the Aisle* depended on the work of its costume designer. Brooks Atkinson commented in his *New York Times* review that "There is a lot to praise in *Two on the Aisle*. . . . [including] Joan Personette's crisp and glowing costumes. . . ."[28] And yet neither the *Time* cover story, nor the *Newsweek* review, or the two-page article about this play in the *New Yorker* magazine mentions Personette, or makes any reference to the importance of her costumes.[29]

Personette took on two other design projects during her years at the Roxy, both in 1953. One was creating the costumes for the Roxyettes' television debut on *The Ed Sullivan Show*. This particular segment had a Scottish theme, the high point of which was an appearance by the famed pipe band of the Royal Highland regiment known as the Black Watch. As the band marched off-stage, sixteen Roxyettes marched on, to perform what Sullivan described as "our country's tribute to one of the greatest fighting regiments in all of world history."[30] Later that same year Personette designed the gowns that Tallulah Bankhead wore for her nightclub debut—at the Sands Hotel in Las Vegas (fig. 12). This gave Personette experience designing for yet another sort of venue.

Joan Personette retired from the Roxy Theatre, and a successful career in theatrical costume design, in 1954. At the age of forty, she was beginning to feel the physical effects of a decade and a half of long hours and constant pressure. Perhaps she was also reacting to recent developments within the American entertainment industry. By mid-century, as the impact of television was growing, and smaller neighborhood movie houses were increasing in number, the demand for Roxy-style extravaganzas had decreased dramatically.[31] Personette was reluctant to end this stimulating phase of her life, but just a few years later, she would commit herself to an entirely different direction: the career of a full-time painter.

Personette as a Studio Artist

A very private individual, Joan Personette only reluctantly discusses the details of her personal and professional lives, or her motivations. But she admits she was excited in 1957 when, after years of having to satisfy the design requirements of her employers, she was finally free to make drawings and paintings exclusively for herself. Financially secure by her early forties, Personette decided to resume her formal studies in art. Nearly a quarter-century after leaving design school, she took the ambitious, and courageous, step of enrolling in Hans Hofmann's summer art program in Provincetown, Massachusetts.[32] By 1957 this aesthetically radical German-born painter (1880–1966) was recognized as "the foremost art teacher in America."[33] During the early years of this century, Hofmann had studied painting in Paris and become part of the avant-garde circles around Picasso, Braque, and other pioneering European modernists, and then opened his first school in Munich in 1915. He emigrated to the United States in 1932, and taught briefly in Berkeley, California, and also in New York, at the Art Students League. In 1933 he started his own school in New York, and his summer school in Provincetown two years later. In 1958, after forty-three years as a teacher, he closed both

schools in order to paint full-time. Thus, Joan Personette was one of Hofmann's last students, and she encountered the master soon after he developed his signature style: large rectangular patches of thickly applied, vivid colors, which establish a dynamic equilibrium on the surface of the canvas and in depth, each rectangle readable as pushing back into the imaginary space of the painting, and also as pulling forward toward the viewer.

Personette maintains that she knew little, at that time, about either Hofmann's work or abstract painting in general. She chose his summer school, she says, purely on the basis of an article she had read about the artist.[34] It may be more remarkable that she stayed there, given the fact that almost all the other students were much younger (she recalls feeling "like some antique") and given the tone of her initial encounter with Hofmann. Personette likes to tell the story of Hofmann's assigning her class to choose an outdoor site and paint a small landscape based on it. She produced a lovely, light-filled scene in the Impressionist manner (pl. 8). At the weekly critique, the students sat out in Hofmann's yard on bleachers, while the class monitors arranged their paintings against a wall. Hofmann walked by a number of examples, then stopped at Personette's canvas, turned to the class, and said, in a booming, heavily accented voice: "We don't paint like that here!" Unfazed, Personette began experimenting with abstraction. Two weeks later at the group critique, Hofmann responded to her new idiom by exclaiming: "This is a perfect painting!" (see pl. 9).

Not surprisingly, Personette's first abstractions recall aspects of Hofmann's work. Although the most prominent forms in plate 9 are three bold, orange-brown arcs, the basic structure of the painting involves a vertical-horizontal grid containing Hofmannesque patches of color; this patchy technique is repeated, in varying shades of white and gray, throughout the background of the composition. Hofmann's influence is also evident in a later abstraction by Personette (pl. 10), a small canvas made up entirely of orange and gray; here, the color patches have been fitted into a grid that resembles a crooked tick-tack-toe board, and there is a good deal of spatial ambiguity. Personette's love of the sensual quality of pigment may also owe something to Hofmann's example. And another, more general, resemblance between the two artists is significant. Discussing art theory, Personette's stated pleasure in improvisation is a sentiment that echoes one frequently expressed by Hofmann.

After her summer in Provincetown, Personette decided to continue her study by taking classes at the Art Students League (fig. 13), a unique New York institution which she had learned about through Hofmann. Founded in 1875, the League is a school with which virtually all American artists of note have been affiliated—as students, teachers, or both— through the middle of this century. It was, and remains, a highly democratic organization, run with much student input, which offers non-credit courses taught by a large selection of respected instructors working in a variety of techniques and styles. Personette exploited this diversity by taking Mario Cooper's watercolor class and a printmaking course conducted by Harry Sternberg. She downplays her expertise as a watercolorist, but some of her most effective paintings (see for example, pl. 23) were executed in this medium. (Unfortunately, it is impossible to discuss Personette's lithographs, since they were lost in a fire that demolished her studio in 1995.) Her preferred media, however, were acrylics and oils. And in view of her years sketching the figure, it is not surprising that the majority of her seven years at the League were spent in life drawing and painting classes, specifically those of Morris Kantor (1896–1974). Personette took classes there from September 1957 through October 1964.

According to Personette, most former Hofmann students who took classes at the League worked with Morris Kantor.[35] Born in Russia, he came to New York as a young man and became known for his wide variety of painting subjects and idioms—including seascapes made on the rocky shores of a Maine island where he liked to vacation, domestic interiors, Cubist figure compositions, and pure abstractions. Personette said she took so many of Kantor's

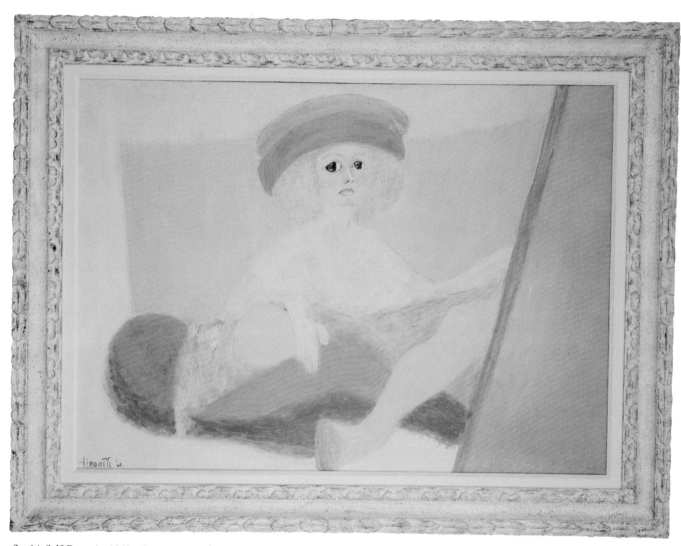

fig. 14. Self-Portrait, *1960, oil on canvas, 30 ³/₄ x 42 inches*

classes because he always used live models but encouraged the students to abstract from them, which she found challenging. Although her work does not directly resemble Kantor's, it is also extremely varied: Personette's figure drawings, paintings, and collages display a number of different approaches to the human form (compare, for example, pls. 13, 14, and 16).

During the years Personette was studying at the League, New York's avant-garde art world went through a series of extraordinary changes. By 1957, the year she began devoting herself to studio art, the gestural side of Abstract Expressionism had become well established as the style of choice for serious young American artists. But by 1964, when she ceased registering at the League, Pop art and the Hard-Edge and Color Field art known as Post-Painterly Abstraction had captured vanguard attention. Though Personette is formally indebted to the painterly, energetic side of Abstract Expressionism (largely channeled through Hofmann), her work is far removed from the introspective, angst-ridden pictures of Willem de Kooning, Lee Krasner, or Jackson Pollock. Likewise, although she occasionally incorporates objects from the everyday world into her collages (see pl. 26), this is not done in the spirit of Robert Rauschenberg, Jim Dine, or other Pop artists. Rather, in her studio art, Personette borrows elements from many sources, for their textural variety or technical challenge, and fuses them into another, very different, sort of work. Helaine Posner has suggested that Personette's physical distance from the center of the Manhattan art world—living, as she continued to do throughout this period, in Purchase, just outside New York City, and, for the past twenty-odd years, in Nevada—"has enabled her to pursue her own course with a sureness and ease that manifests itself in the work."[36] Certainly geography has played a part in the development of Personette's art. However, she has never been truly isolated: she has always made regular forays into Manhattan, and she shows an obvious interest in the works of several European and American modern masters, from Matisse to Milton Avery.

Virtually all of Personette's extant studio output consists of paintings, drawings, and collages. These fall into three broad categories: figures (including portraits), landscapes, and abstractions—many of which can be read as highly stylized variations on one of the other types. Although Personette's studio art bears little direct resemblance to her costume renderings, they share a number of characteristics: an emphasis on stylistic variety, implied movement, and a sensual combination of textures and colors. Personette also tends to work in series, which seems a logical outgrowth of her Roxy experience, which required her to create numerous variations on a given theme. Vivacious execution and a sense of humor are also present in Personette's studio art, and undoubtedly have their roots in her earlier work.

Perhaps most important, the two aspects of Personette's artistic output are linked by their emphasis on sheer aesthetic pleasure. Although the Roxyettes performed military numbers, these were not political commentary but displays of patriotic pride designed to help sell Victory Bonds. Likewise, in her studio work Personette seems to have adopted the philosophy of Henri Matisse, as quoted at the beginning of this essay. Matisse is the quintessential example of an artist whose work does not reflect his own life: on the evidence of his joyous forms and rich colors, one would never guess that he had financial troubles, marital difficulties, and several serious illnesses, or lived through two world wars. Like the great French master, Personette believes that the purpose of her art is to provide enjoyment, for herself and her viewers, not to make political statements or exorcise personal demons. And, as noted above, although her studio work refers to some of the major developments in modern art during the second half of this century, Personette quickly fused all these influences into her own style.

The Figure: Drawings, Paintings, and Collages

Personette seems to have drawn and painted the figure more than any other subject, an affinity doubtless strengthened by her long experience drawing people for her theatrical work. *Robelaine* (pl. 11) is a half-length portrait of a young African-American girl who caught her eye while she and Dreyfus were on their honeymoon in the American South in 1939. Even though some parts of the painting are left unfinished, the composition is visually satisfying. Its rich, dark palette and broad brushstrokes recall Personette's *Negro Chieftain*, made six years earlier, and the paintings of children executed by New York's Ash Can painters during the first decades of this century. *Robelaine* demonstrates Personette's increasing artistic skills, and the asymmetrical placement of the figure gives a pleasingly informal quality to this dignified yet also very engaging image.

At the Art Students League Personette produced handsome academic studies of the nude in oil crayon and charcoal. This training is reflected in *Jack*, 1963 (pl. 12), a full-length drawing of her former husband seen from above as he reclines on a couch. Dreyfus's casual pose indicates both his continued closeness to the artist—from whom he had been separated for some twenty years when this drawing was executed—and his own personality. Despite his intimidating resumé, Dreyfus is known as a warm, rather whimsical man.[37] The color scheme used here—muted purples, blues, orange, and brown—has been one of Personette's favorites throughout her painting career.

In the early 1960s, too, Personette began exploring figures constructed from a few, large flat areas of color. These are some of her strongest compositions, and they also reflect her admiration for the work of several other artists. Personette's *Pink Nude*, 1961 (pl. 14), refers to a celebrated painting by Matisse, which she knows well.[38] While Matisse's figure is reclining and heavily outlined, the overall concept of Personette's composition, including the pose, color, and title, evokes his canvas. The pose of *Reclining Figure with One Arm Raised*, 1982 (pl. 15), also relates to Matisse. These are faceless, anonymous figures, which nevertheless have a strong sense of humanity, and curving silhouettes that are particularly appealing to the eye. Although she insists that her knowledge of art history is limited, Personette could have seen the French master's works in New York galleries and museums and during her travels with the Skating Vanities. Her trip to Paris was undoubtedly important in this regard, and of course the Hermitage is famous for its collection of early twentieth-century European painting, particularly the works of Matisse.

The Hermitage also owns two paintings by the French artist Marie Laurencin (1885–1956) who, like Personette, produced both studio and commercial art. Laurencin created book illustrations and designed wallpaper and textile patterns, as well as sets and costumes for the Ballets Russes. Her generalized, faux-naïve portraits have a flat, decorative quality resembling that of many of Personette's pictures. Laurencin is the only female artist whom Personette has mentioned as a role model; she owns one of the French painter's drawings.

Throughout her painting career Personette has moved back and forth among a number of different styles. At several points in the 1960s and seventies she produced a series of pictures of women related to the work of Pierre Bonnard (1867–1947), one of the painters known as Nabis. Like canvases typical of the French artist, Personette's *Woman with a Teapot*, c. 1975 (pl. 13), depicts a solitary female figure within a heavily patterned environment dominated by pastel hues. Personette finds poetry in an ordinary moment: as the woman pauses, looking down at her cup, the lush landscape of Lake Tahoe—where Personette had recently moved—beckons beyond the picture window.

Personette admired not only early modern European figuration but also the work of artists closer to her own generation. In choosing to learn from the American painter Milton Avery (1893–1965) and Kenzo Okada (1902–1982), a painter from Japan who settled in New York in 1950, Personette showed her independence of dominant art world

trends. In the noisy heydays of Abstract Expressionism and Pop art, both these artists explored arrangements of big planes of pale, flat color, with softly blurred edges, which produce a quiet, contemplative mood. Personette readily acknowledges the influence of both artists' work.

Reared in Hartford, Connecticut, where he also attended art school, Avery moved to New York City in 1925 and began experimenting with a variety of painting styles.[39] It was only in the mid-1940s, when he was past fifty, that Avery developed the type of work for which he is best known today: abstracted, quirkily drawn figures, still lifes, and landscapes, made up of carefully calibrated pastel colors which achieve a subtle visual balance. Avery's paintings are generally described as harmonious, poetic, and serene, a spirit characteristic of much of Personette's art. Although based in New York, Avery spent the summer of 1957 in Provincetown, Massachusetts, where he lived in a house next door to the one Personette was renting. Oddly, the two artists never met. But Personette notes that she has long admired Avery's work, which she could easily have seen at many venues in New York, including the Grace Borgenicht Gallery, which held regular one-man exhibitions for Avery during the years Personette was studying at the Art Students League, and the Whitney Museum of American Art, which mounted a major Avery retrospective in 1960, the year before Personette painted her *Pink Nude*. Avery's painting has often been compared to that of Matisse, another affinity that attracted Personette to his art.

Personette was introduced to Kenzo Okada by a fellow student at the League, but she knew and had been impressed by his work earlier. Okada had solo exhibitions at the Betty Parsons Gallery in New York, one of Personette's favorites, in 1953, 1955, 1956, and for many years thereafter; moreover, Jack Dreyfus owns several paintings by Okada. Although his art is totally nonrepresentational, Okada's muted palette and quiet sensibility are related to Avery's work and in turn helped reinforce Personette's.[40]

During the mid-1980s Personette created one of her most successful series, of a highly abbreviated female figure seated with one elbow resting on her knee, her hand raised, partially covering her face. Some versions include bold, colorful patterns in the fabric of the woman's blouse, or vestigial indications of facial features. But the strongest example of this series (pl. 16) is also the simplest. Here Personette eliminates the face, the fabric patterns, and almost all bright colors. What remains is an exceedingly handsome arrangement of black, brown, and beige forms, enlivened by a few thin orange lines and—a masterly stroke—two areas of corrugated paper which add a rich surface texture and a surprising sense of depth. This series demonstrates especially well Personette's ability to fuse stylistic borrowings from other artists into a new form.

Landscapes: New York, Maine, and the West

During a given decade, Personette has generally worked on more than one type of subject at a time. The second broad category of Personette's studio art is landscape. A lifelong swimmer, she has an obvious affinity for the natural environment around her. The seashore and forest-encircled lakes have inspired works throughout her career. And the vistas of her successive homes and travels have launched her imagination. After living for more than two decades in Purchase, in the early 1970s Personette moved to the other end of the country: Nevada. Her first exposure to this part of the West came in 1961, when she and Dreyfus decided to divorce. Because New York state laws were strict, she traveled to Nevada to file the necessary papers. While there, she stayed in what she describes as "an old-fashioned cabin" on Lake Tahoe, and was immediately overwhelmed by the beauty of the place. Personette returned there regularly to escape New York summers; after a few years she bought a home on the lake.

A few of Personette's landscapes are identifiable views of specific sites. But most are generalized evocations, providing the simplest information about water, mountains, and trees. Like her figure paintings, they reduce their subject matter to their visual essences. An example is her *Landscape Tondo*, c. 1965 (pl. 19), part of a series in which she varies the colors of each segment of the canvas, but retains that popular Renaissance format, the circular or tondo painting. These landscapes show off one of Personette's best qualities as a painter: her ability to manipulate thick, creamy dollops of pigment to suggest undulating hillsides, roiling streams, far distant mountains, and cloud-filled skies.

Less romantic, but equally effective, are Personette's many landscapes influenced by Japanese art. The history of *Japonisme*—the appropriation of Japanese artistic forms by Western cultures—is well documented, most notably in 19th-century France. Many of Milton Avery's flat stylized landscapes also have obvious Japanese roots and, as noted above, Personette was interested in the abstraction of Kenzo Okada, in which floating forms in asymmetrical arrangements seem Eastern in idiom. She also traveled to Japan in the early 1970s, and visited people and sites through introductions made by Okada. Thus, the relationship between Personette's landscapes and Japanese art is a rich one.

Personette skillfully contrasts patterned and monochrome areas to create a sense of space in her Japanese-inflected watercolor, *Maine Beach*, 1965 (pl. 23). The most intriguing work in a particularly successful series, this painting was inspired by visits to an island that Dreyfus owned off the coast of Maine. Dreyfus—who owns several paintings from this series—acknowledges its heritage by hanging it between two 19th-century prints from Japan. In yet another adaptation of Japanese tradition, Personette painted two large tripartite folding screens around 1969, uniting them with summarily brushed landscapes that span all three sections (see pl. 24).

Not all of Personette's landscapes are related to Japanese art. For example, *Western Landscape*, 1977 (pl. 20), combines simplified planes with bold outlines and several passages of heavy impasto to create a powerful, energetic image. In his review of Personette's 1990 retrospective at the National Museum of Women in the Arts in Washington, D.C., Eric Gibson singled out her *Western Landscape* series, describing them as "quite accomplished, particularly in the way she uses color to suggest the season and time of day."[41] Similarly, the vertical *Stylized Landscape* of the early 1970s (pl. 21) is one of a larger group of pictures in which Personette delights in luscious paint and implied motion: here the brushstrokes cascade down the center of the canvas and into the river below.

Abstractions

Very few of Joan Personette's paintings, drawings, or collages are pure abstractions; most suggest either a highly stylized figure or a landscape. One clear exception is an early collage, called *Dreyfus Fund*, 1959 (pl. 25). It contains a great deal of recognizable imagery, and several personal references: print advertisements for the Fund, including its famous lion symbol; a photograph of the trophy Dreyfus won for his innovative advertising campaigns; and a Polaroid of Joan and Jack's young son holding his pet dog.

Ever since the Cubists introduced collage into painting around 1912, it has inspired artists to use unlikely, often humble materials. Personette is adept at incorporating such media into her works, and she has experimented with collage, off and on, throughout her career as a studio artist. After a hiatus of several years, she became interested in making collages again in 1967, during a lengthy hospital stay. Bored with the slow process of recuperation, she desperately wanted to make art, but she had no access to her usual materials. So she improvised, collecting bits of detritus that came her way. From these, she fashioned a set of inventive collages, combining pieces of brown paper bags with the wrappers of her hospital cutlery and, in plate 26, even her plastic patient-identification bracelet.

The fresh, unstudied quality of these collages undoubtedly derives from the way Personette created them. She states that she never knows what will happen after she begins work: she might, for example, start by scraping the label off a package, and then let the materials suggest what the next step should be. These collages are not completed in one sitting; rather, Personette prefers to work on them on several occasions, but she retains their spontaneous air.

The sense of humor that enabled Personette to create successful costumes for such broad comedies as *Hellzapoppin* and *Two on the Aisle* reemerges, in a subtler form, to add a note of levity to some of her collages. One of the best examples is *Abstraction*, 1987 (pl. 31), which turns strips of corrugated paper and a Macy's shopping bag with the store's logo into a balanced, visually enticing pattern. Another of Personette's recent collages (pl. 32) demonstrates that even her simplest, sparest works can conjure up images from the outside world. It is not difficult to read this as a stylized landscape, with the sun in the right-hand corner and a turquoise body of water at the base.

Recognition—A Matter of Politics

Although Personette has worked in the creative professions for more than six decades, neither her theatrical costume renderings nor her paintings have received much formal recognition. Given the vagaries of the art world and her own lack of self-promotion, the limited attention given her studio art is not surprising. But it does seem odd that it should be difficult to locate information about her career in costume design, and about variety entertainment in general. Until recently theater historians have been reluctant to deal with popular entertainment of the sort presented at the Roxy, and the parallel tendency of art historians to focus exclusively on studio art, when an artist has also produced significant applied designs, reveals a narrow-minded, elitist tendency that persists today—despite considerable progress—in both fields. This issue merits a brief discussion here.

One might reasonably assume that the increasing visibility being accorded couturiers, as exemplified by the exhibitions of the Metropolitan Museum of Art's Costume Institute and such surveys as the 1997–98 "Best Dressed: 250 Years of Style" at the Philadelphia Museum of Art, would also raise the status of individuals who design actual costumes, those worn by performers on stage. The growing respect for fashion (and, by extension, theatrical costume design) as a legitimate kind of fine art has one root in the designs made for ballets and plays by such distinguished early twentieth-century painters and sculptors as Natalya Goncharova, Sophie Täuber-Arp, and Pablo Picasso. But the status of theatrical costume designers has been slow to rise. In fact, judging from recent reference books, the theater world remains mired in a complex, and highly political, system of hierarchies and definitions. For example, Personette is either not listed, or given extremely short shrift, in standard dictionaries, encyclopedias, and histories of the theater, apparently because she spent most of her time designing costumes for a chorus line whose members sang and danced in a popular movie palace—which, technically, is not a "theater." Today the singing and dancing members of the chorus in a Broadway musical belong to Actors' Equity, the same union as the performers in a nonmusical play. But members of chorus lines, like the one at Radio City Music Hall, join AGVA (the American Guild of Variety Artists)—an important aesthetic, and class, distinction. The inherent inequity of this two-tiered system becomes clear when one considers the term "legitimate" theater, which did not apply to the popular entertainment produced at the Roxy.

In its own way, this is another version of the century-old dispute about what constitutes "high," versus "low," art. To some critics, no costume rendering can be considered "art," because it is made as a step toward the fabrication of a costume, which has a specific, practical function. (The theatrical establishment makes further distinctions among types of costumes that it considers more, or less, worthy of respect. For example, in Washington, D.C., the John F. Kennedy

Center for the Performing Arts regularly displays one or two opera costumes in vitrines located inside the theater lobbies; it does not show the costumes for the more popular entertainments presented at the Center.) The problem of recognition for costume designers is especially difficult because they have traditionally been at the very bottom of the theatrical hierarchy, no matter what kind of theater is involved.

While Personette probably could not have received her due as a designer because of historic prejudices built into the American theater system, recognition for her studio art is another matter. She has never actively sought acclaim, and in fact she often remarks that she makes art only for herself. Even if she had been eager to find gallery representation, however, she might have won little sympathy for her work. In the years when Abstract Expressionism, Pop, and Minimal art absorbed leading American painters and dominated media attention, it is hard to imagine that any artist, especially an unknown, middle-aged woman who was producing consistently unfashionable paintings, could have achieved much critical, or material, success. However, the art and the art criticism of the 1990s are multifaceted, and are moving beyond the long-held notion of linear "progress" in painting, or the traditional concept of avant-gardes. Perhaps the present climate, in which the muted, contemplative, yet sensuously satisfying paintings of Avery, Okada, and others are being reevaluated, will work in Personette's favor.

In any case, Joan Personette remains a tough, strong-minded person. Today, at eighty-three, she has been temporarily thwarted from making art by a recent illness, but she still seems to have much of the energy of her youth. She hopes to return to her studio soon. Meanwhile, she remains an intriguing painter in a visual language that is gaining critical attention, and an important link to early 20th-century American theatrical history.

Acknowledgments

Many people have given generously of their time in order to discuss various aspects of Joan Personette's life and art with me. I particularly wish to acknowledge Professor William Pucilowsky, Alyce Gilbert, Jared Aswegan, Jill K. Heller, Susan Chiang, and Lee Ann Mitchell, for sharing their expertise in the area of theatrical costume design; Brooks McNamara and Reagan Fletcher, Director and Assistant Archivist, respectively, of the Shubert Archives in New York, and Lawrence Robinson, Historian and Archivist of United Scenic Artists' Local 829, for their many valuable insights; Mrs. Muriel ("Duffy") Hake, Mrs. Fern Dion Gedney, and Evelyn Ray Ashley, former Roxyettes and/or Rockettes, for their insiders' view of the Roxy and related matters; John Lahr, for his reminiscences about his father; Professor Toby Zinman, for many insights and suggestions regarding theater history and politics; and Christopher Davis, for his expert guidance in terms of theatrical research; Linda Rice-Johnston and Ralph Pemberton, for helpful information about the Black Watch; Stephanie Cassidy, for locating invaluable archival materials from the Art Students League; Mrs. Gert Kahn, for illuminating perspectives on her longtime friend, Joan Personette; Michael Zaidman, Director and Curator of the National Museum of Roller Skating; as well as Brett Topping, Lila Snow, Robert G. Regan, Dr. Jules Heller, and Gloria Heller, for assistance in matters political, aesthetic, and editorial; Leigh Snitiker and Anne Hoy, of Exhibitions International, for their intelligent, untiring, and thorough work on this endeavor; Jack Dreyfus, who personally conducted a tour of his art collection; Helen C. Raudonat and the rest of the staff of the Dreyfus Medical Foundation; and, of course, Joan Personette, who cheerfully endured countless intrusions into her life for the sake of this project.

N.G.H.
Philadelphia, Pa.
December 1997

Notes

1 See Jack Flam, *Matisse on Art* (Berkeley: University of California Press, 1995), 35.

2 All statements by Joan Personette, and biographical information about her, come from an extensive series of interviews with the author and visits to her Reno and Lake Tahoe, Nevada homes in summer and fall 1997.

3 For information on this, and related establishments, as well as illuminating comments on wartime fabric and design restrictions, see Caroline Rennolds Milbank, *New York Fashion: The Evolution of American Style* (New York: Abrams, 1989).

4 George R. Kernodle, *Invitation to the Theatre* (New York: Harcourt, Brace & World, 1967), 493.

5 Samuel L. Rothafel (1882–1936), "one of the great American showmen of the twentieth century," opened his first theater (in Forest City, Pennsylvania) in 1908, and his innovative ideas about programming—combining films with live vaudeville—soon brought him to the attention of New York's theatrical moguls. Between 1913 and 1934, he headed no fewer than seven Manhattan theaters, including Radio City Music Hall, which opened December 27, 1932. (Anthony Slide, *The Encyclopedia of Vaudeville* [Westport, Conn.: Greenwood Press, 1994], 439–40.)

6 It was later surpassed by Radio City Music Hall. Note that today's typical Broadway theater seats between 1,200 and 1,400 patrons.

7 For additional statistics on the Roxy, see Lucinda Smith, *Movie Palaces* (New York: Clarkson N. Potter, 1980), 14ff.

8 See Slide, *Encyclopedia of Vaudeville*, 97–98.

9 Barbara Naomi Cohen-Stratyner, *Biographical Dictionary of Dance* (New York: Schirmer, 1982), 338.

10 For a contemporary description of Gae Foster in action, see John Chapman, "Mainly about Manhattan," *New York Daily News* (August 14, 1938): n.p. Like many of the sources cited here, this can be found in the New York Public Library's Billy Rose Theatre Collection at Lincoln Center.

11 They also made less money, as was recently confirmed to me in September 1997 interviews with Mrs. Fern Dixon Gedney, Evelyn Ray Ashley, and Mrs. Muriel ("Duffy") Hake who danced with both organizations. These details about the Roxyettes should make it clear that their resemblance to traditional showgirls—like those of the Ziegfeld Follies or the Las Vegas casinos—is only superficial.

12 E. J. Kahn, Jr., "A Reporter at Large: The Kids," *New Yorker* (January 21, 1939): 42, 44.

13 "House Reviews" in *Variety*, published September 25, 1940 (140, no. 3, p. 55, by "Scho."); September 10, 1941 (144, no. 1, p. 38, by "Hobe"); October 1, 1941 (144, no. 4, p. 28, by "Herb"); July 22, 1942 (147, no. 7, p. 39, by "Hobe"); and March 17, 1943 (150, no. 1, p. 19, by "Hobe").

14 A large selection of Partington's Roxy photos can be found in the New York Public Library's Billy Rose Theatre Collection.

15 Many others were destroyed in a fire at her Lake Tahoe studio in the summer of 1995.

16 She was, of course, eligible for *Two on the Aisle*, in 1951. But that season's Tony Award for Outstanding Costume Design was given to the well-known Broadway designer Irene Sharaff, for *The King and I*. For additional information, see Lee Alan Morrow, *The Tony Award Book: Four Decades of Great American Theatre* (New York: Abbeville, 1987). There were no alternate awards for designers at the movie palaces.

17 See Morrow, pp. 215–264, for a complete list of Tony awards given between 1947 and 1986. For a few years the Costume Design award was presented next to last (preceding the one for Outstanding Backstage Technician) and when that category was abolished, just before the one for Lighting Design. But otherwise, the Costume Design category has always been last.

18 Interviews with several designers confirmed these facts, but most helpful was a telephone conversation (November 11, 1997) with Lawrence Robinson, Historian and Archivist for Local 829 of United Scenic Artists in New York. He noted that costume designers are treated equally poorly in the film industry. I would also like to thank Brooks McNamara, Director of the Shubert Archives, for a very helpful discussion of related matters, November 5, 1997.

19 Regarding his love for movies, see Dreyfus's autobiography, *The Lion of Wall Street* (Washington, D.C.: Regnery Publishing, 1996), 185. Many years later, he coproduced several films and a Broadway play. On page 44 of this book he refers to Personette's "magnificent" costume sketches. He also points out that she played an important role in designing the interiors of his New York City office and several other properties.

20 It was also revived in 1949, 1967, and 1976, but with considerably less success. For details, see Ken Bloom, *American Song: The Complete Musical Theatre Companion. 1877–1995* (New York: Schirmer, 1996), 2nd ed., vol. 1, 467–68.

21 This is Personette's term. It is a commentary on the continuing undervaluation of costume design that none of the theater reference books I consulted gives the name of the original costume designer for *Hellzapoppin* (one incorrectly listed Personette). Nevertheless, this first Broadway connection represented genuine recognition of her talent. It was mentioned, for example, in a full-page 1940 newspaper advertisement by Ohrbach's department store announcing its collection of original evening gowns designed by the "sparkling" Joan Personette. (See *New York World Telegram*, October 31, 1940.)

22 Information on the Skating Vanities comes from issue 36 (October 1993) of "Historical Roller Skating Overview," the monthly newsletter of the National Museum of Roller Skating in Lincoln, Nebraska; the recently published book, *The History of Roller Skating*, by James Turner and Michael Zaidman (Lincoln, Neb.: National Museum of Roller Skating, 1997), 49 and 81–82; "Nord Star," an unsigned article from the Sports section of *Newsweek* magazine (August 30, 1943): 76; and a French periodical, *Point du vue: Images du monde* (May 4, 1950): 5–7.

23 George Freedley, "The Stage Today: Gae Foster's 'Skating Vanities' is Entertaining, Lively Performance," [New York] *Morning Telegraph* (June 6, 1944): n.p.

24 Lahr, best known today for his film role as the Cowardly Lion in *The Wizard of Oz*, was fifty-six when *Two on the Aisle* opened. Dolores Gray (née Crevoin) was then twenty-seven. She made her Broadway debut in 1944, and also appeared in several films. (See "Two on the Aisle" by Eugene Burr, *Theatre Arts* 35, no. 9 [September 1951]: 22–23ff.)

25 Uncredited review, "New Play," in *Newsweek* (July 30, 1951): 47; and Brooks Atkinson, "At the Theatre," in the *New York Times* (July 20, 1951): 13. For a fascinating account of Bert Lahr's experiences in this play, see the biography written by his son, John Lahr (*Notes on a Cowardly Lion* [New York: Alfred A. Knopf, 1969], 247–252).

26 *Time* (October 1, 1951): article on pp. 46–52.

27 It was a real uniform, donated by a noted second baseman. Ibid., 46.

28 Atkinson, "At the Theatre," 13.

29 John Lardner, "The Theatre," *New Yorker* (July 28, 1951): 48, 50.

30 I wish to thank the staff of Sofa Entertainment in Los Angeles for making a videotape of this program available to me.

31 In a last-ditch attempt to keep up with the times, the Roxy introduced the newly invented "Cinerama" screen in 1958, but abandoned its live stage show.

32 The catalogue for the 1990 National Museum of Women in the Arts exhibition incorrectly gives the year when Personette attended Hofmann's school as 1959.

33 Cynthia Gooding, *Hans Hofmann* (Munich: Prestel, 1990), 68.

34 Although she does not recall where she saw this article, presumably it was one that appeared in conjunction with Hofmann's 1957 retrospective at the Whitney Museum of American Art in New York.

35 See Anita Ventura, "The Paintings of Morris Kantor," *Arts* (May 1956): n.p.

36 Helaine Posner, *Joan Personette: A Retrospective Exhibition* (Washington, D.C.: The National Museum of Women in the Arts, 1990): n.p.

37 See Marshall Smith, "Jack Dreyfus: Maverick Wizard behind the Wall Street Lion," *Life* (February 11, 1966): 70–82.

38 As a gift for Dreyfus she once made a very convincing, full-size copy of Matisse's *Pink Nude* (the Matisse, dated 1935, is in the Baltimore Museum of Art)

39 See Barbara Haskell, *Milton Avery* (New York: Whitney Museum of American Art, 1960), an authoritative monograph on this artist.

40 See the exhibition catalogue, *Kenzo Okada* (New York: Marisa del Re Gallery, 1980).

41 Eric Gibson, "Art," *Washington* [D.C.] *Times* (November 1, 1990): E-3.

PLATES: ON STAGE

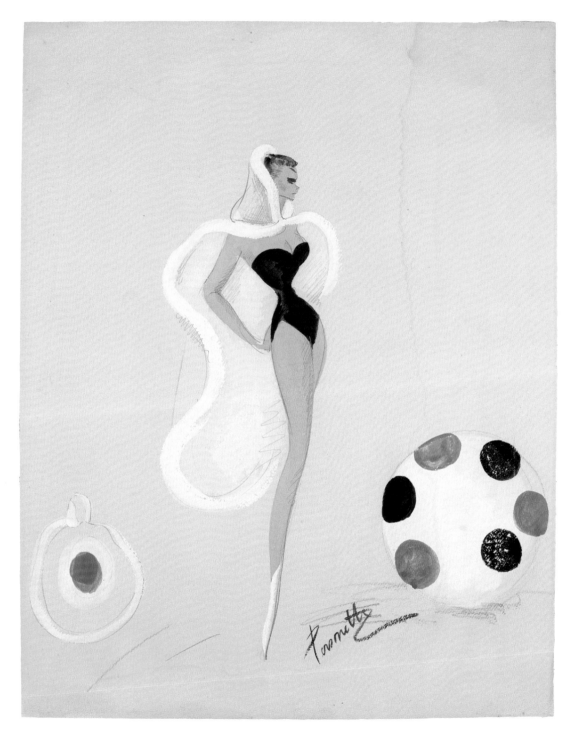

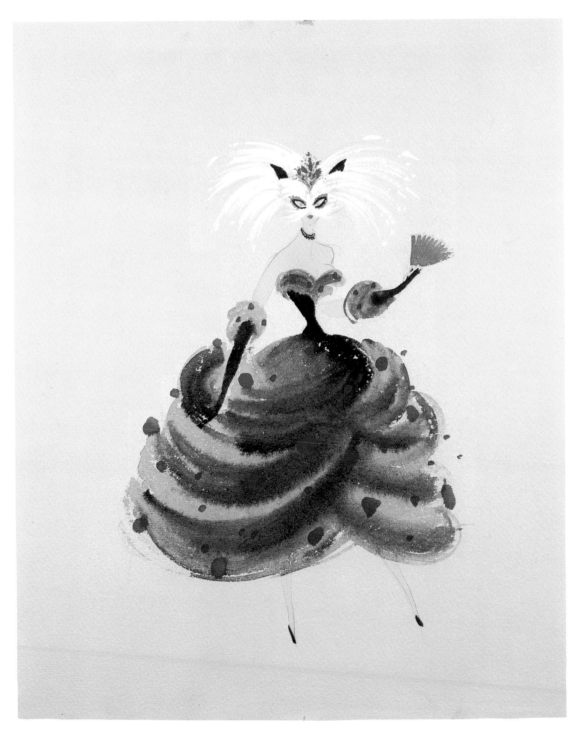

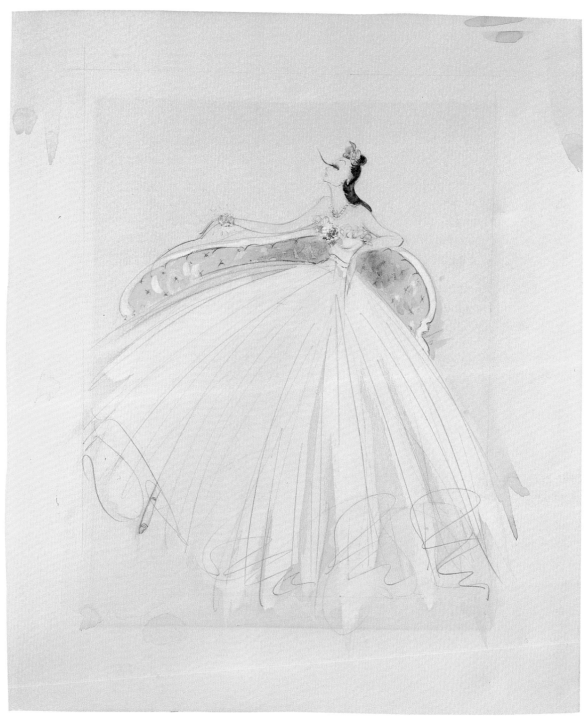

pl. 3.

Woman Lounging on Chaise (Costume Rendering), 1940s,

tempera and pencil on paper, 17 x 13 $^{7}/_{8}$ inches

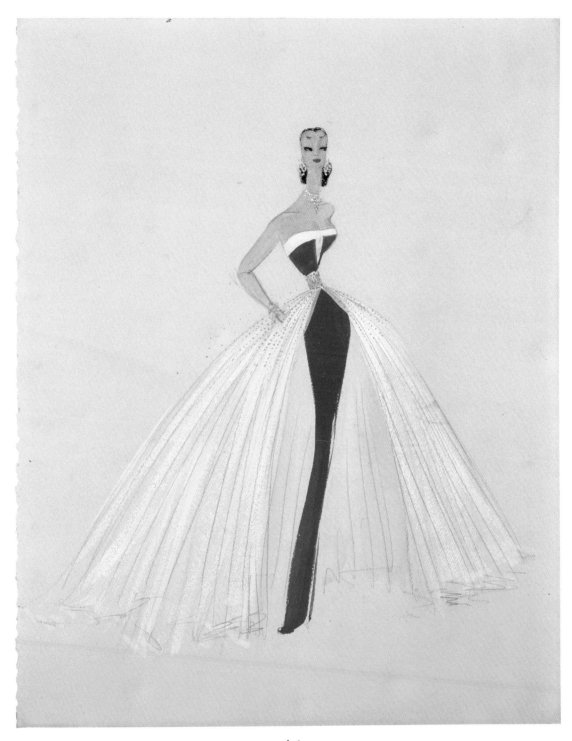

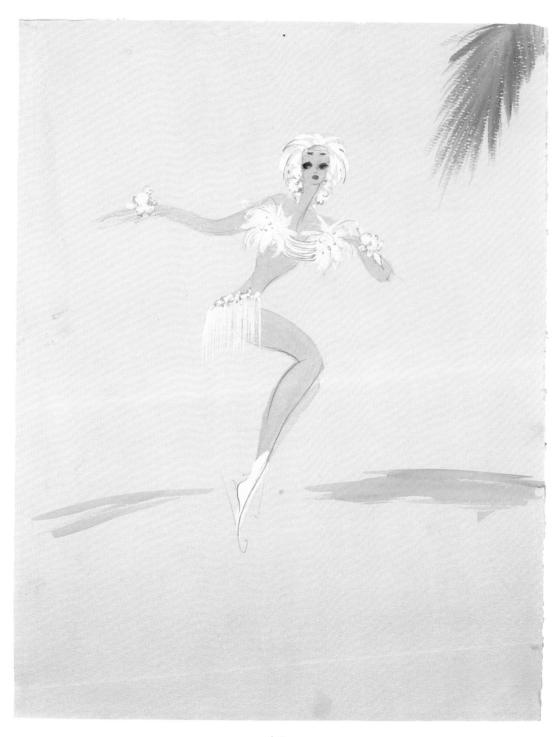

pl. 5.

Jumping Skater in White (Costume Rendering), 1940s,
tempera and pencil on paper, 13 ¹/₄ x 10 inches

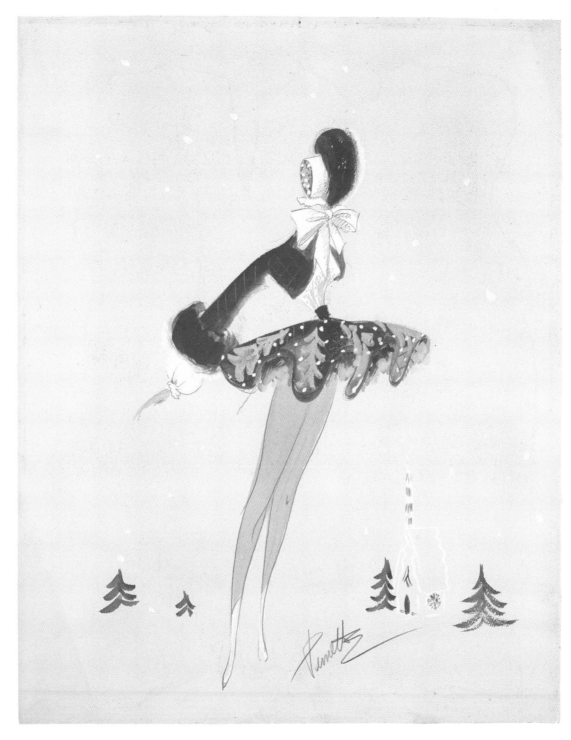

pl. 6.

Skater in Red Dress with Falling Snow (Costume Rendering), 1940s,

tempera and pencil on paper, 16 $^7/_8$ x 13 inches

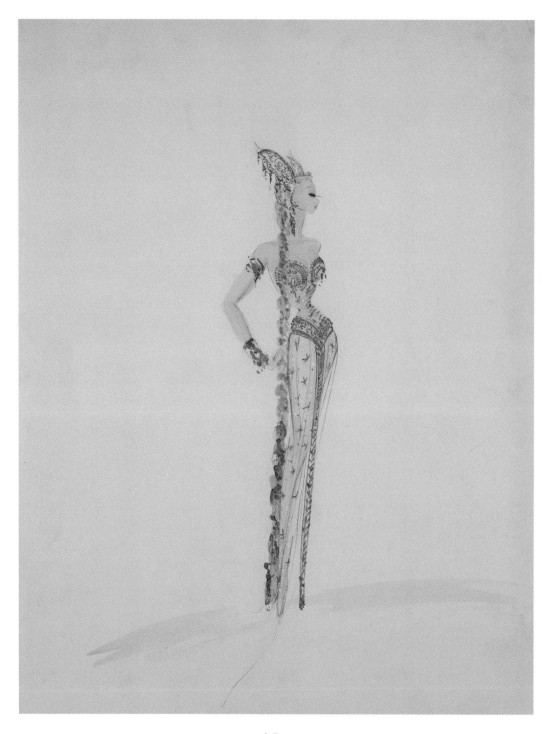

pl. 7.

"Valkyrie" from "Two on the Aisle" (Costume Rendering), c. 1951,

tempera and pencil on paper (original lost)

PLATES: ON CANVAS

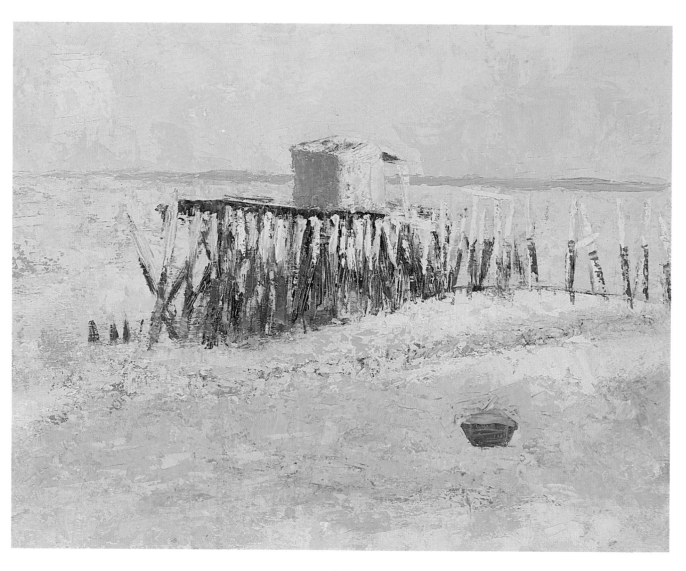

pl. 8.

Provincetown View, 1957,

oil on canvas, 16 x 19 ³/4 inches

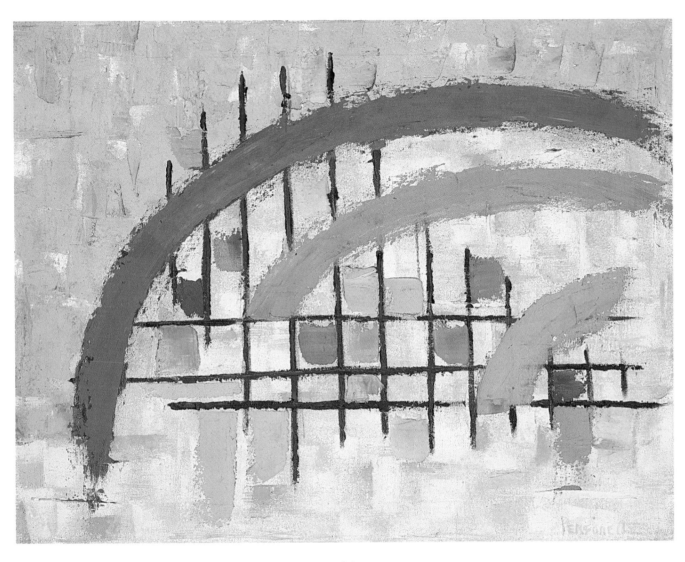

pl. 9.

Abstraction, 1957,

oil on canvas, 21 $^1/_2$ x 27 $^1/_2$ inches

pl. 10.

Abstraction, c. 1977,

oil on canvas, 9 x 12 inches

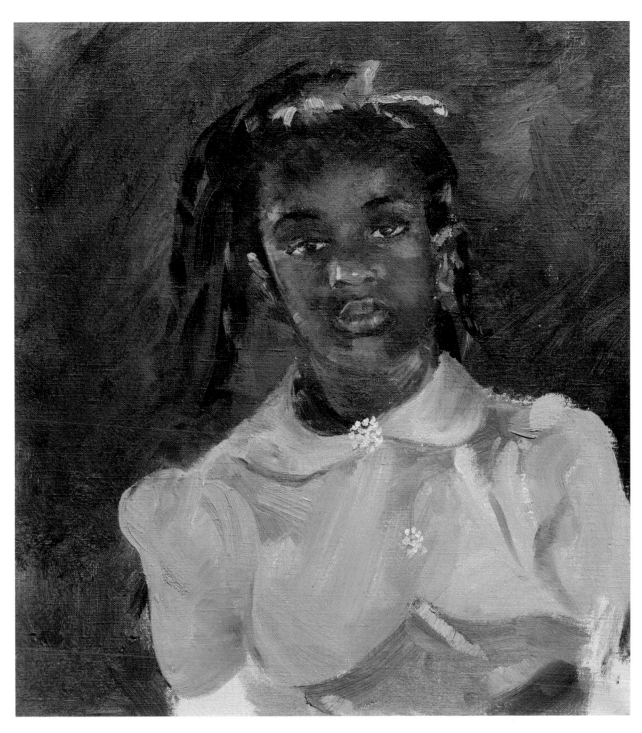

pl. 11.

Robelaine, 1939,

oil on canvas, 17 $^3/_8$ x 15 $^3/_8$ inches

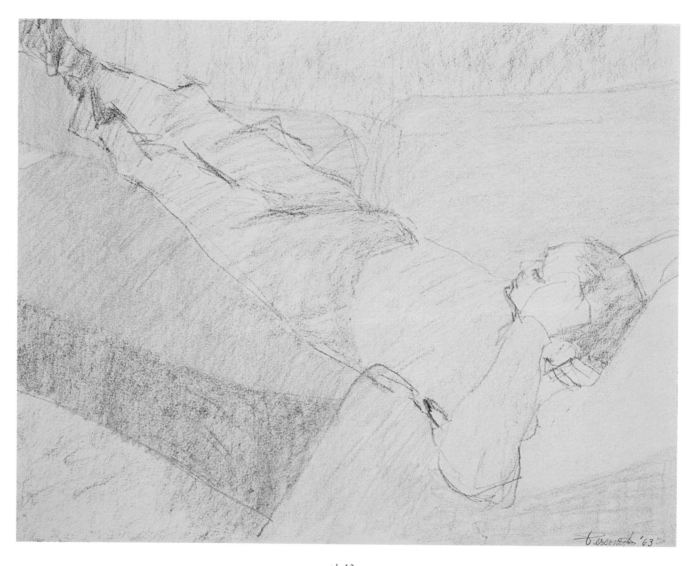

pl. 12.

Jack, 1963,

oil crayon on paper, 12 $^3/_4$ x 16 inches

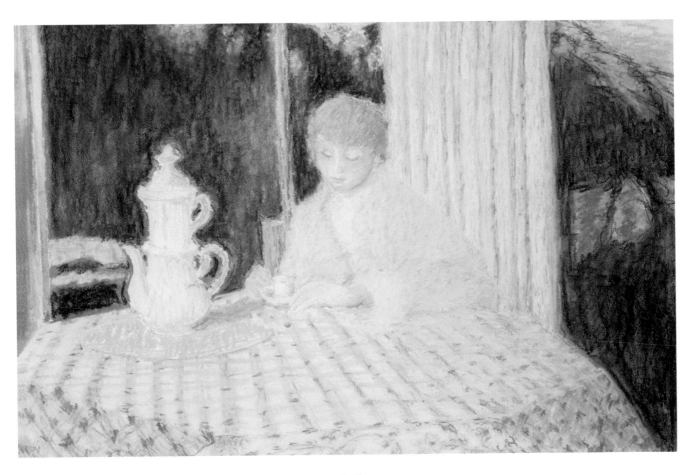

pl. 13.

Woman with a Teapot, c. 1975,

pastel and pencil on paper, 13 ¹/₄ x 20 inches

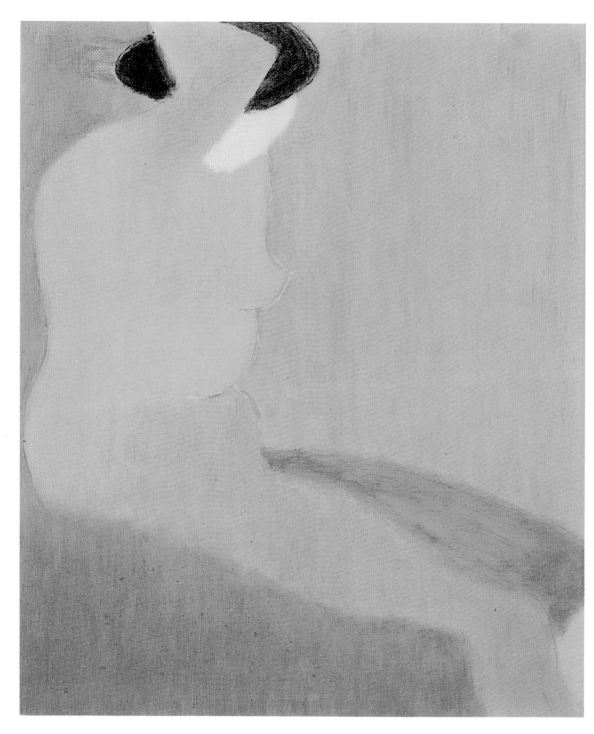

pl. 14.

Pink Nude, 1961,

oil on canvas, 29 x 24 inches

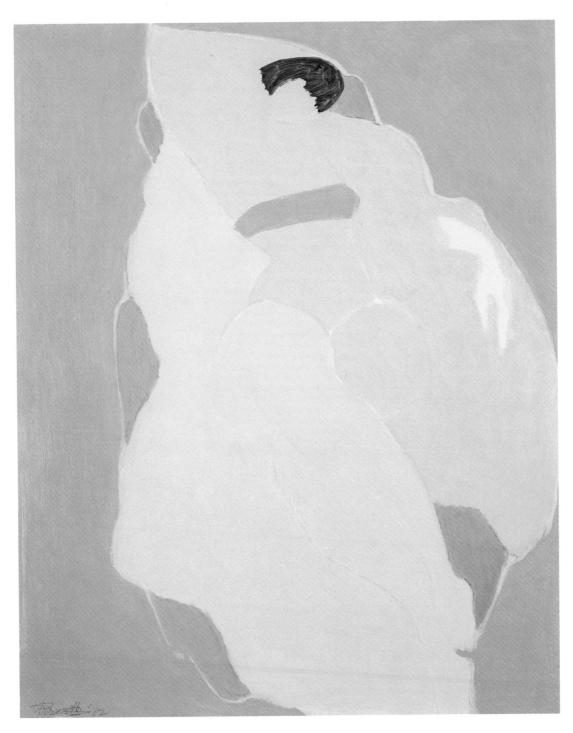

pl. 15.

Reclining Figure with One Arm Raised, 1982,

oil on paperboard, 18 x 14 inches

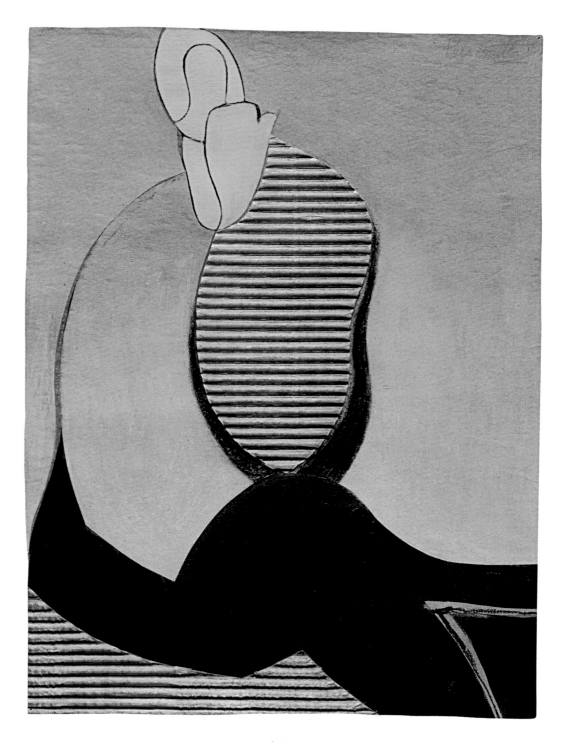

pl. 16.

Figure, 1985,

corrugated paper and oil crayon on paper, 15 $^{1}/_{8}$ x 11 $^{1}/_{4}$ inches

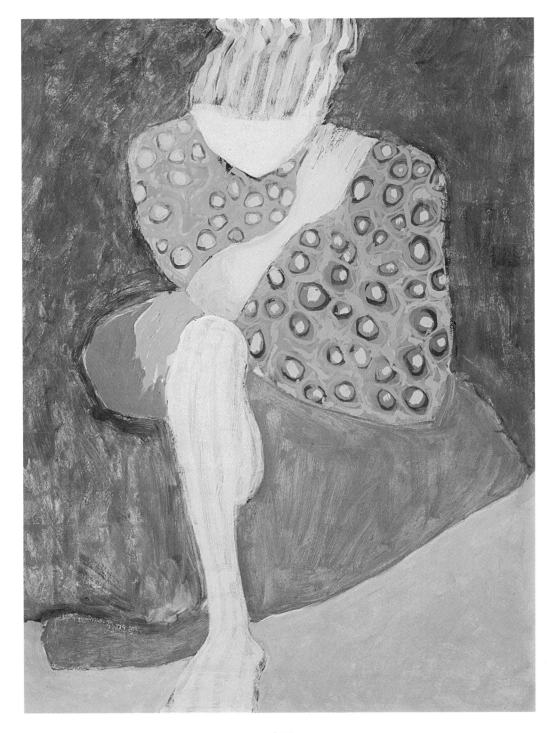

pl. 17.

Figure, 1962,

acrylic on paper, 39 $\frac{1}{2}$ x 29 $\frac{1}{2}$ inches

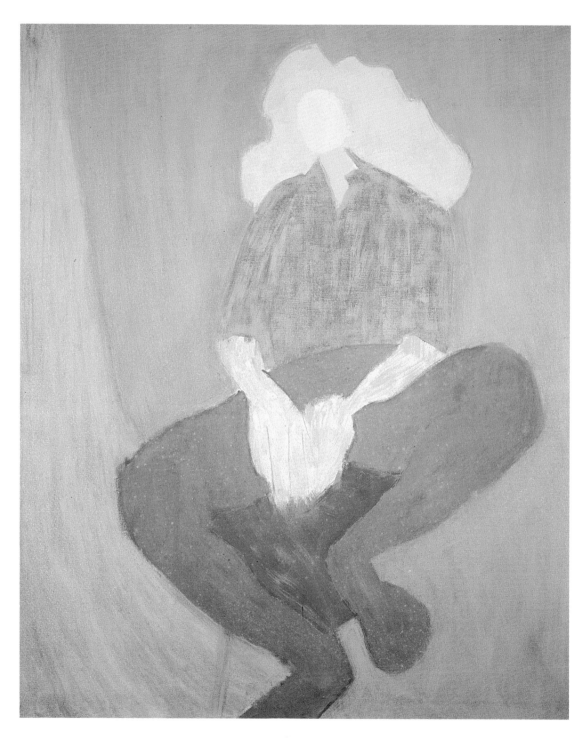

pl. 18.

Helen, 1966,

oil on canvas, 50 $^1/_4$ x 40 inches

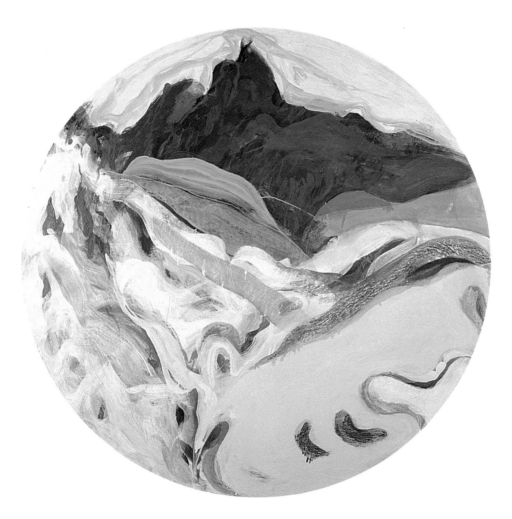

pl. 19.

Landscape Tondo, c. 1965,

oil on canvas, dia. 20 inches

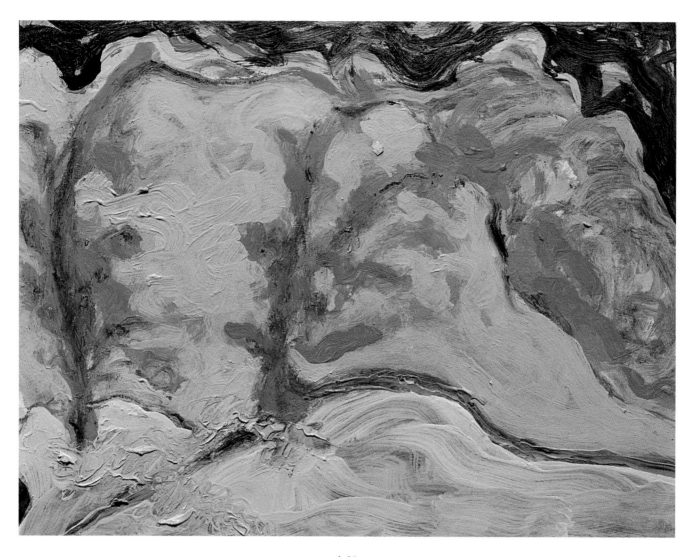

pl. 20.

Western Landscape, 1977,

oil on paperboard, 7 $^3/_8$ x 9 $^3/_8$ inches

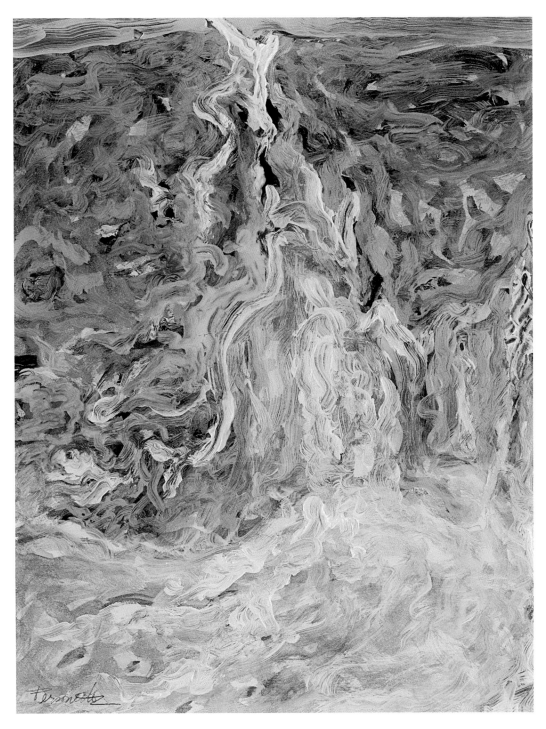

pl. 21.

Stylized Landscape, early 1970s,

oil on paper, 11 x 8 ¹/₄ inches

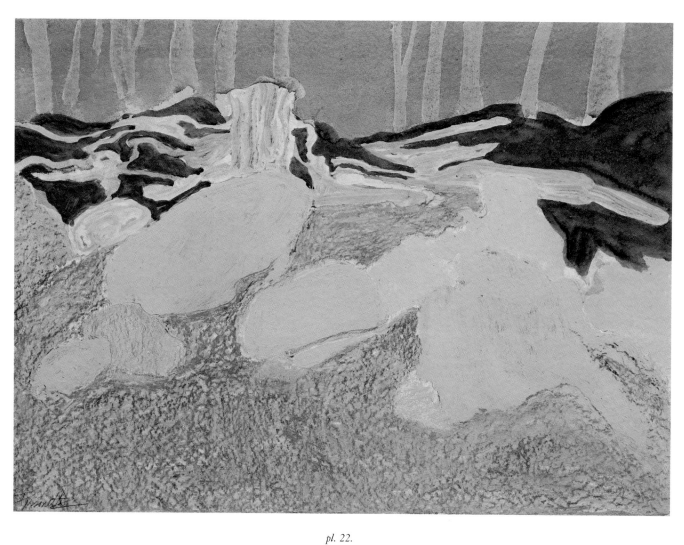

pl. 22.

Maine Beach, 1964,

oil and oil crayon on paper, 15 $\frac{1}{4}$ x 20 inches

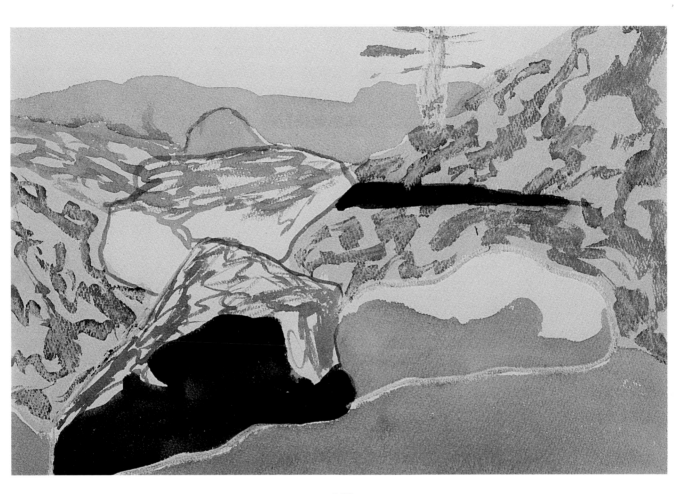

pl. 23.

Maine Beach, 1965,

watercolor on paper, 9 $^1/_2$ x 13 $^1/_2$ inches

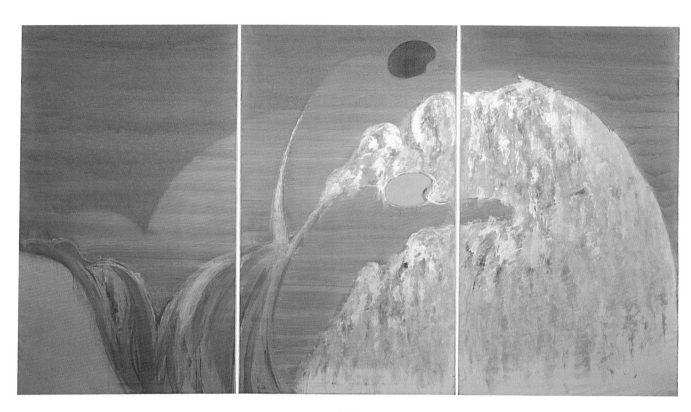

pl. 24.

Stylized Landscape (folding screen), c. 1969,

oil on canvas, 72 ¹/₂ x 126 inches

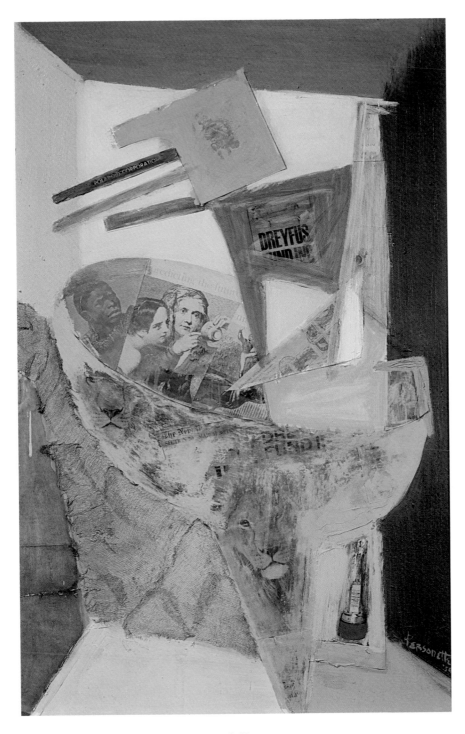

pl. 25.

Dreyfus Fund, 1959,

oil, paper, and gauze on canvas, 38 x 24 inches

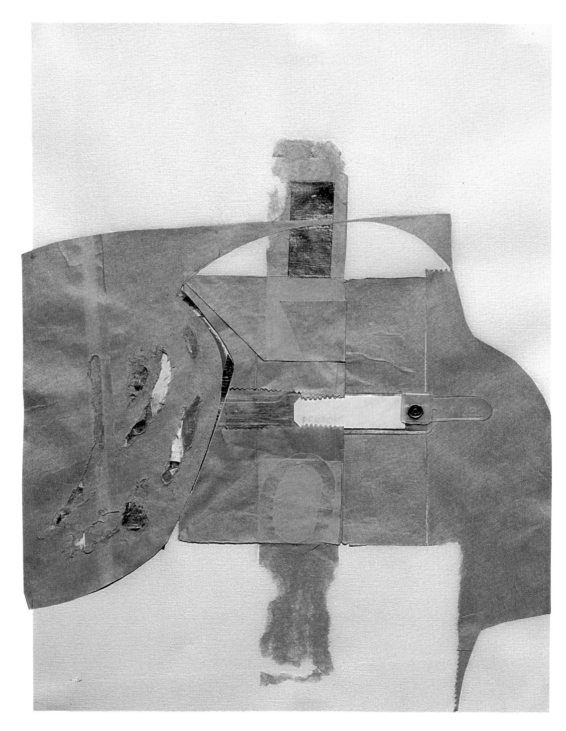

pl. 26.

Abstraction, 1967,

brown paper, acrylic, foil, and plastic on paper, 15 $^3/_4$ x 11 $^7/_8$ inches

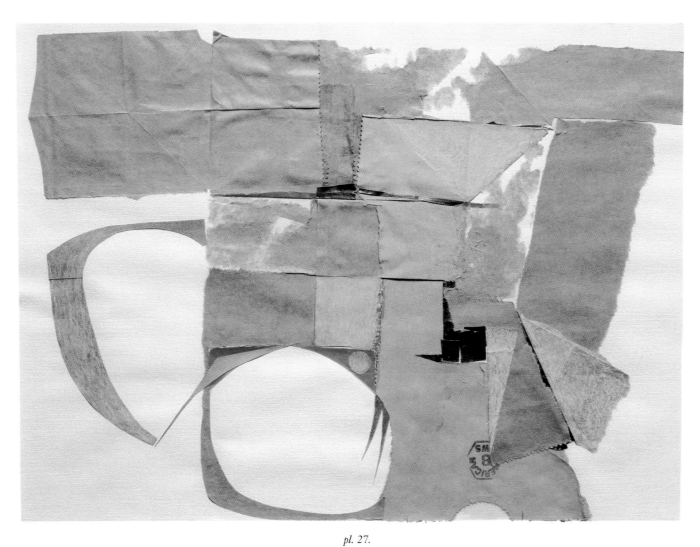

pl. 27.

Abstraction, 1968,

brown paper, oil crayon, and foil on paper, 12 x 15 $^{7}/_{8}$ inches

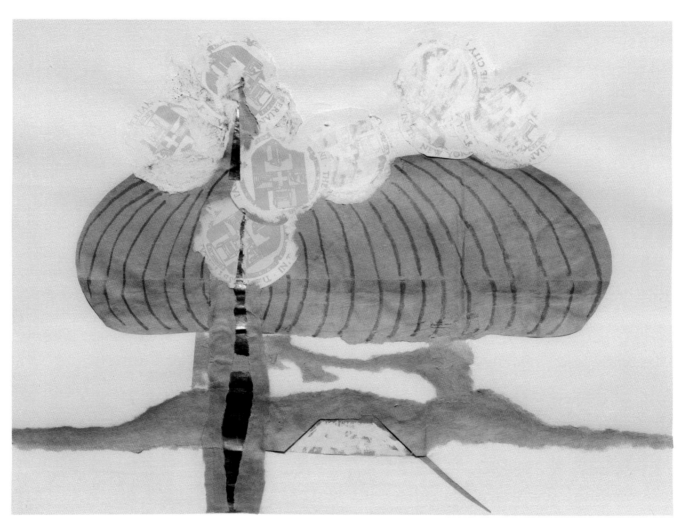

pl. 28.

Abstraction, 1967,

brown paper, acrylic, oil crayon, and foil on paper, 11 $^{7}/_{8}$ x 15 $^{3}/_{4}$ inches

pl. 29.

Abstract Head, 1984,

tissue and oil crayon on board, 11 ³/₄ x 17 ¹/₂ inches

pl. 30.

Moons, 1975,

tissue paper and oil crayon on paper, 16 ³/₄ x 33 inches

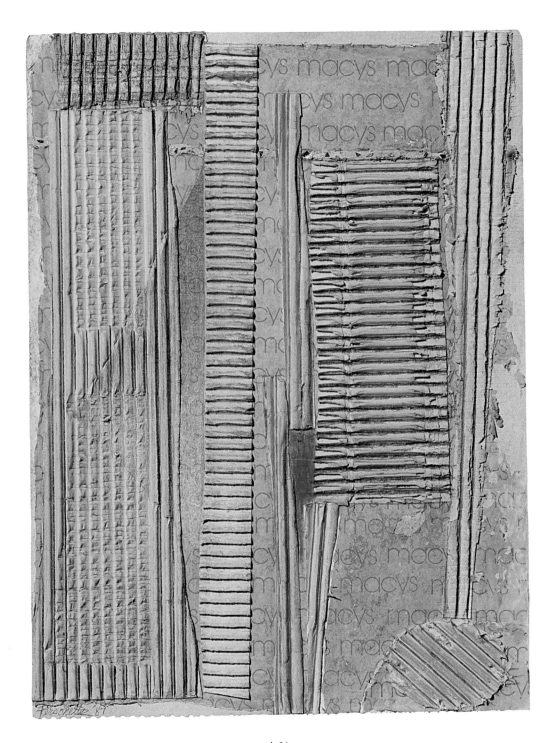

pl. 31.

Abstraction, 1987,

corrugated paper and oil crayon on paper, 13 ¹/₂ x 10 inches

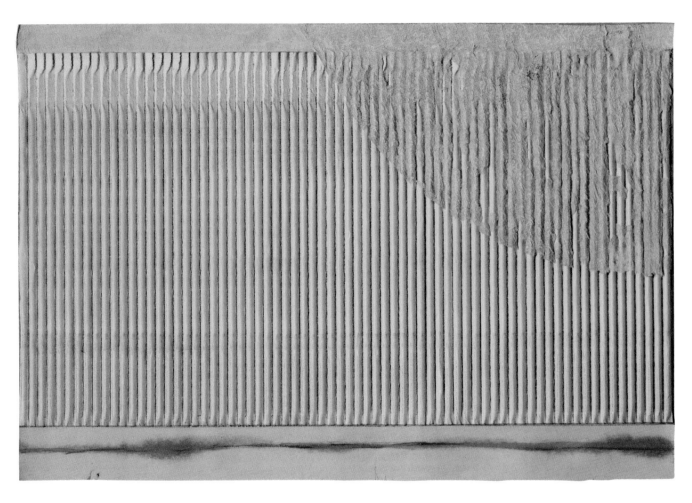

pl. 32.

Abstraction, 1985,

corrugated paper and oil crayon on paper, 12 x 17 $^{1}/_{8}$ inches

INTRODUCTION

1. **Elegant Lady in Gown with
 Train,** c. 1920
 colored crayon on paper
 9 x 7 inches
 Collection of the artist

2. **Woman in Suit with Fur Piece,**
 c. 1931
 watercolor on paper
 19 x 10 $^{1}/_{2}$ inches
 Collection of the artist
 fig. 2

COSTUME RENDERINGS FOR
THE ROXY THEATRE,
1939–54

3. **Woman Lounging on Chaise**
 (Costume Rendering), 1940s
 tempera and pencil on paper
 17 x 13 $^{7}/_{8}$ inches
 Collection of the artist
 pl. 3

4. **Woman in Pink Dress with Top
 Hat** (Costume Rendering), 1940s
 tempera and pencil on paper
 19 x 12 $^{7}/_{8}$ inches
 Collection of the artist

5. **"Madame La Zorza"** (Costume
 Rendering), 1940s
 tempera and pencil on paper
 9 x 6 $^{7}/_{8}$ inches
 Collection of the artist

6. **Woman in Cat Mask** (Costume
 Rendering), 1940s
 tempera and pencil on paper
 17 $^{3}/_{4}$ x 14 inches
 Collection of the artist
 pl. 2

7. **Woman with Fencing Foil**
 (Costume Rendering), 1940s
 tempera and pencil on paper
 10 $^{5}/_{8}$ x 7 $^{3}/_{4}$ inches
 Collection of the artist

8. **Woman in Folk Dress** (Costume
 Rendering), 1940s
 tempera and pencil on paper
 18 $^{3}/_{4}$ x 15 $^{3}/_{4}$ inches
 Collection of the artist

9. **Woman in Black and White
 Skirt** (Costume Rendering), 1940s
 tempera and pencil on paper
 20 $^{3}/_{4}$ x 15 $^{3}/_{4}$ inches
 Collection of the artist

10. **Woman in Red Sheath with
 White Overskirt** (Costume
 Rendering), 1940s
 tempera and pencil on paper
 17 x 13 $^{3}/_{4}$ inches
 Collection of Jack Dreyfus
 pl. 4

11. **Woman with Red Parasols**
 (Costume Rendering), 1940s
 tempera and pencil on paper
 16 $^{5}/_{8}$ x 14 $^{5}/_{8}$ inches
 Collection of Jack Dreyfus

12. **Man in Plaid Jacket** (Costume
 Rendering), 1940s
 tempera and pencil on paper
 16 $^{3}/_{4}$ x 14 $^{1}/_{2}$ inches
 Collection of Jack Dreyfus

13. **Man in Harem Pants** (Costume
 Rendering), 1940s
 tempera and pencil on paper
 13 x 10 $^{1}/_{2}$ inches
 Collection of Jack Dreyfus

14. **"Maryland"** (Costume
Rendering), 1940s
tempera and pencil on paper
8 $^7/_8$ x 6 $^7/_8$ inches
Collection of the artist

15. **Woman with Polka-dotted Ball**
(Costume Rendering), 1940s
tempera and pencil on paper
17 $^1/_4$ x 13 $^5/_8$ inches
Collection of the artist
pl. 1

ADDITIONAL COSTUME RENDERINGS, 1940–53

16. **Jumping Skater in White**
(Costume Rendering), 1940s
tempera and pencil on paper
13 $^1/_4$ x 10 inches
Collection of Jack Dreyfus
pl. 5

17. **Skater in Red Dress with Falling
Snow** (Costume Rendering), 1940s
tempera and pencil on paper
16 $^7/_8$ x 13 inches
Collection of the artist
pl. 6

18. **"Circus Harlequin"** (Costume
Rendering), c. 1951
tempera and pencil on paper
16 $^3/_4$ x 12 $^3/_4$ inches
Collection of the artist

19. **Poster for "Two on the Aisle,"**
c. 1951
22 $^1/_4$ x 14 inches
Collection of the artist

20. **Poster for Tallulah Bankhead's
nightclub act at The Sands, Las
Vegas,** 1953
10 $^1/_2$ x 6 $^7/_8$ inches
Collection of the artist
fig. 12

THE FIGURE: DRAWINGS, PAINTINGS, AND COLLAGES

21. **Negro Chieftain,** 1933
oil on canvas
18 x 15 $^3/_4$ inches
Collection of the artist
fig. 4

22. **Robelaine,** 1939
oil on canvas
17 $^3/_8$ x 15 $^3/_8$ inches
Collection of Jack Dreyfus
pl. 11

23. **Nude Study,** c. 1957
charcoal on paper
25 x 18 $^7/_8$ inches
Collection of Jack Dreyfus

24. **Self-Portrait,** 1960
oil on canvas
30 $^3/_4$ x 42 inches
Collection of Jack Dreyfus
fig. 14

25. **Self-Portrait,** c. 1960-63
oil on canvas
36 x 24 inches
Collection of the artist

26. **Pink Nude,** 1961
oil on canvas
29 x 24 inches
Collection of the artist
pl. 14

27. **Figure,** c. 1961
oil on canvas
26 x 21 inches
Collection of Jack Dreyfus

28. **Figure,** 1962
acrylic on paper
39 $^1/_2$ x 29 $^1/_2$ inches
Collection of Jack Dreyfus
pl. 17

29. **Jack,** 1963
oil crayon on paper
12 $^3/_4$ x 16 inches
Collection of the artist
pl. 12

30. **Figure with Slipper,** 1966
oil crayon on paper
25 x 19 inches
Collection of Jack Dreyfus

31. **Helen,** 1966
oil on canvas
50 $^1/_4$ x 40 inches
Collection of Jack Dreyfus
pl. 18

32. **Nude in Interior,** early 1970s
pastel on paper
20 x 18 inches
Collection of the artist

33. **Two Women in Interior,** early
1970s
pastel on paper
24 x 18 inches
Collection of the artist

34. **Woman with a Teapot,** c. 1975
pastel and pencil on paper
13 $^1/_4$ x 20 inches
Collection of Jack Dreyfus
pl. 13

35. **Reclining Figure with One Arm
Raised,** 1982
oil on paperboard
18 x 14 inches
Collection of the artist
pl. 15

36. **Figure,** 1984
oil on paperboard
39 $^1/_2$ x 29 $^1/_2$ inches
Collection of the artist

37. **Seated Figure,** 1984
oil crayon on paper
17 1/$_2$ x 23 inches
Collection of Jack Dreyfus

38. **Figure,** 1985
corrugated paper and oil crayon on paper
15 1/$_8$ x 11 1/$_4$ inches
Collection of the artist
pl. 16

LANDSCAPES: NEW YORK, MAINE, AND THE WEST

39. **Provincetown View,** 1957
oil on canvas
16 x 19 3/$_4$ inches
Collection of the artist
pl. 8

40. **Landscape,** 1957
oil on canvas
15 x 8 inches
Collection of the artist

41. **Maine Beach,** 1964
oil and oil crayon on paper
15 1/$_4$ x 20 inches
Collection of Jack Dreyfus
pl. 22

42. **Landscape,** c. 1965
oil on canvas
11 x 37 inches
Collection of the artist

43. **Landscape Tondo,** c. 1965
oil on canvas
dia. 20 inches
Collection of the artist
pl. 19

44. **Landscape Tondo,** c. 1965
oil on paper
dia. 28 inches
Collection of the artist

45. **Maine Beach,** 1965
watercolor on paper
9 1/$_2$ x 13 1/$_2$ inches
Collection of Jack Dreyfus
pl. 23

46. **Stylized Landscape** (folding screen), c. 1969
oil on canvas
72 1/$_2$ x 126 inches
Collection of the artist
pl. 24

47. **Landscape,** c. 1970
oil crayon on paper
7 5/$_8$ x 10 1/$_2$ inches
Collection of the artist

48. **Landscape,** early 1970s
oil on canvas
11 7/$_8$ x 15 7/$_8$ inches
Collection of Jack Dreyfus

49. **Stylized Landscape,** early 1970s
oil on paper
11 x 8 1/$_4$ inches
Collection of the artist
pl. 21

50. **Landscape,** early 1970s
oil on canvas
8 3/$_8$ x 11 inches
Collection of the artist

51. **Landscape** (miniature paper screen), c. 1975
watercolor on paper
10 1/$_2$ x 25 1/$_2$ inches
Collection of Jack Dreyfus

52. **Western Landscape,** 1977
oil on paperboard
7 3/$_8$ x 9 3/$_8$ inches
Collection of the artist
pl. 20

ABSTRACTIONS

53. **Abstraction,** 1957
oil on canvas
21 1/$_2$ x 27 1/$_2$ inches
Collection of Jack Dreyfus
pl. 9

54. **Dreyfus Fund,** 1959
oil, paper, and gauze on canvas
38 x 24 inches
Collection of Jack Dreyfus
pl. 25

55. **Abstraction,** 1967
brown paper, acrylic, oil crayon, and foil on paper
11 7/$_8$ x 15 3/$_4$ inches
Collection of Jack Dreyfus
pl. 28

56. **Abstraction,** 1967
brown paper, acrylic, foil, and plastic on paper
15 3/$_4$ x 11 7/$_8$ inches
Collection of Jack Dreyfus
pl. 26

57. **Abstraction,** 1968
brown paper, oil crayon, and foil on paper
12 x 15 7/$_8$ inches
Collection of the artist
pl. 27

58. **Abstraction,** late 1960s
oil crayon, paper labels, and brown paper on paper
12 1/$_2$ x 15 1/$_2$ inches
Collection of the artist

59. **Decorative panel for Jack Dreyfus's private airplane,** 1974
acrylic on canvas
20 1/$_2$ x 8 3/$_4$ inches
Collection of Jack Dreyfus

60. **Moons,** 1975
tissue paper and oil crayon on
paper
16 ³/₄ x 33 inches
Collection of the artist
pl. 30

61. **Abstraction,** c. 1977
oil on canvas
9 x 12 inches
Collection of Jack Dreyfus
pl. 10

62. **Sun,** 1984
tissue paper and oil crayon on
paper
11 ¹/₂ x 14 ¹/₂ inches
Collection of Jack Dreyfus

63. **Abstract Head,** 1984
tissue and oil crayon on board
11 ³/₄ x 17 ¹/₂ inches
Collection of Jack Dreyfus
pl. 29

64. **Abstraction,** 1985
corrugated paper and oil crayon on
paper
12 x 17 ¹/₈ inches
Collection of the artist
pl. 32

65. **Abstraction,** 1987
corrugated paper and oil crayon on
paper
13 ¹/₂ x 10 inches
Collection of the artist
pl. 31